THE
Archive Photographs
SERIES

STUBBINGTON
AND
TITCHFIELD

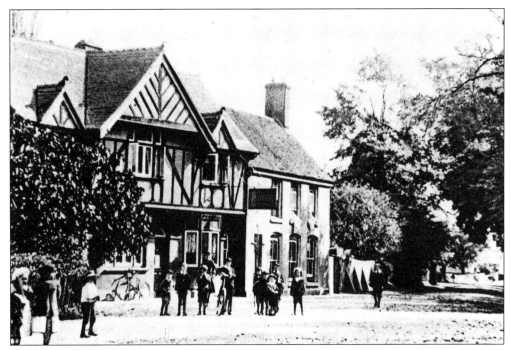

Stubbington Green, 1903.

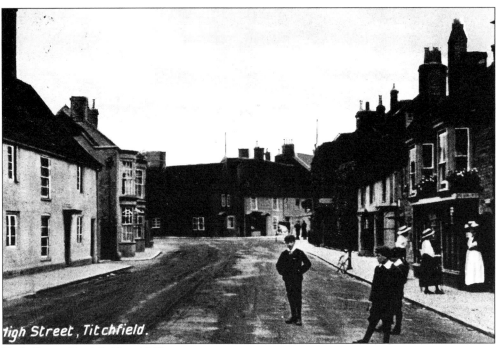

High Street, Titchfield, c. 1910.

THE
Archive Photographs
SERIES

STUBBINGTON
AND
TITCHFIELD

Compiled by
Ron Brown

CHALFORD

First published 1997
Copyright © Ron Brown, 1997

The Chalford Publishing Company
St Mary's Mill, Chalford,
Stroud, Gloucestershire, GL6 8NX

ISBN 0 7524 1005 9

Typesetting and origination by
The Chalford Publishing Company
Printed in Great Britain by
Bailey Print, Dursley, Gloucestershire

For my Grandchildren

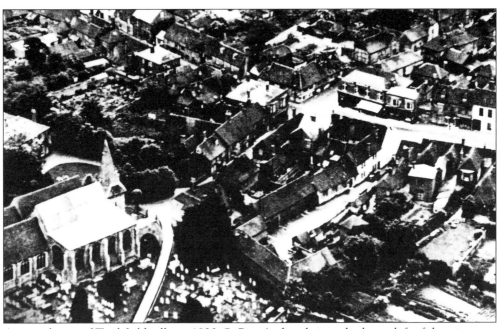

An aerial view of Titchfield village, 1930. St Peter's church is in the lower left of the picture.

Contents

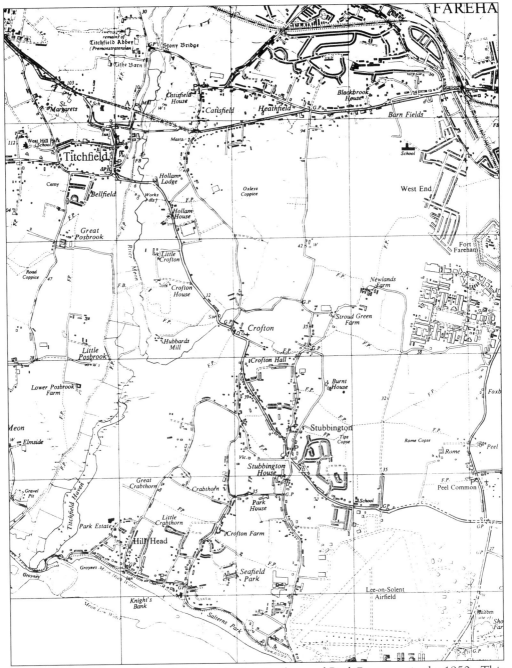

A map of Stubbington and Titchfield, including Crofton and Peel Common, in the 1950s. This was before the increase in housing and commercial development took place.

Introduction

Catering for the great interest that has been shown over the past twenty years or so by people wanting to know more about their surroundings, many books concerning local history have been produced in Britain, generally featuring the larger towns and cities. This is a pity in many ways for, when one ventures out beyond the tram tracks a wealth of history and interest may be found in the surrounding villages and hamlets too.

The villages of Stubbington and Titchfield in Hampshire are a prime example because for many years they have lived in the shadow of larger neighbouring towns such as Gosport and Fareham who would no doubt point out that they have had to survive in the shadow of cities such as Portsmouth and Southampton. And yet, if we go back to around the middle of the sixteenth century, Titchfield was quite an important place in the county, with Fareham being described as 'a small village close to the ancient town of Titchfield'. My, how times change.

Much of Titchfield's early prosperity was down to the fact that it was a thriving sea port, for the sea came right into Titchfield, behind the church and up to the old tannery - where traces of wharves were found. But this all changed in 1611 when the Third Earl of Southampton, wishing to reclaim the large stretch of sea-marsh lying between Titchfield and the haven at Hill Head, built a sea wall across the mouth of the River Meon. Understandably, this did not earn the Earl any points in the popularity stakes, and to this day his effigy is burned annually at the Titchfield bonfire carnival.

Stubbington, referred to as 'Stubitone' in the Domesday Book, came under the umbrella of Crofton, or 'Croftune' in the aforementioned book. There has always been some confusion as to where Crofton and Stubbington begin and end, but in times past Crofton extended from the outskirts of Titchfield to Stubbington village.

We cannot pretend that Stubbington was as important as Titchfield in early times, it chiefly comprised farms and could not boast of being a sea port or having an ancient abbey. Neither did it attract a long line of royal personages or famous names like its neighbouring village, although William Shakespeare is reputed to have visited Stubbington in order to witness the sports of bull-baiting and cudgel-fighting.

So, why 'Stubbington and Titchfield', why combine the two? Well, apart from the fact that they are but a few miles distance from the one village centre to another, Stubbington and Crofton came under Titchfield parish for many years.

The ancient parish of Titchfield was very extensive, its foreshore ran seven miles from Stokes Bay to the River Hamble, including Swanwick, Hook, Funtley, Segensworth, Chark, Lee, Peel Common, Crofton and Stubbington. In 1871 Crofton became a separate ecclesiastical parish, and by 1878 its population had increased such that a new church, Holy Rood, was built in Stubbington to relieve the Old Crofton church.

It is interesting to reflect that prior to 1930, Lee-on-the-Solent came under the Crofton

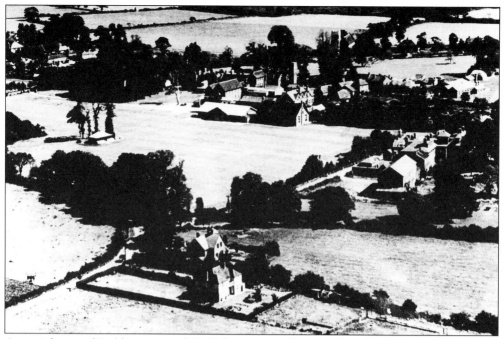

An aerial view of Stubbington, with Bells Lane in the foreground, in the 1930s.

parish, but it was not a happy union, with Mr Foster of Stubbington House describing Lee as a 'carbunkle in the neck of Crofton parish'. However, Lee was taken over in 1930 by Gosport Borough Council, who at the time nurtured the plans to also take over Crofton and Hill Head, but it was not to be and they have remained under the control of Fareham Borough Council.

Having the opportunity to look back on the past of Stubbington and Titchfield via pictures is a local historian's delight, for today the two villages provide a complete contrast to each other. Titchfield village today looks very much as it did one hundred years ago, the villagers taking great pride in the fact that it won 'Hampshire's best kept village' for two years running - 1987 and 1988. On the other hand, Stubbington village centre has changed considerably over the past thirty years, from a few old buildings around the Green to a bustling shopping centre, the oldest thing left being the wooden war memorial that was only erected there in 1922.

They may live in the shadow of large towns and cities, but I am sure that reader's embarking on this pictorial excursion in to their past will agree that Stubbington and Titchfield have a story to tell.

Ron Brown
July 1997

One
Highways and Byways

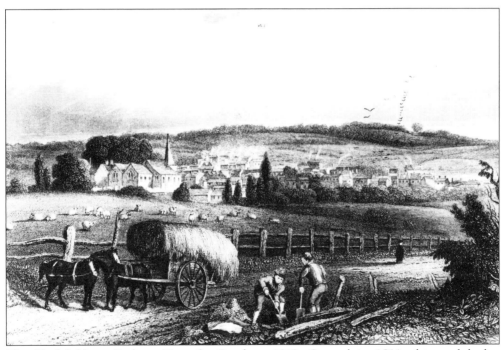

The Titchfield to Cosham Turnpike Road, *c.* 1812. Opened in 1811, this road had a considerable effect on the appearance of Titchfield for, prior to its construction, the route from Fareham to Titchfield had to pass through Catisfield village down Fishers Hill to the Anjou Bridge, then along Mill Lane into the village.

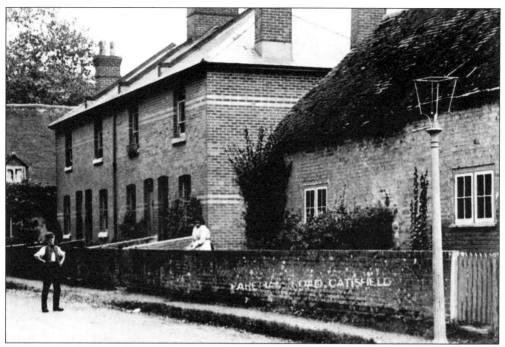

Fareham Road, Catisfield, *c.* 1910. It is incredible now to reflect that this was the main highway linking Titchfield with Fareham before by-pass roads were constructed, thus allowing Catisfield to retain part of its rural charm.

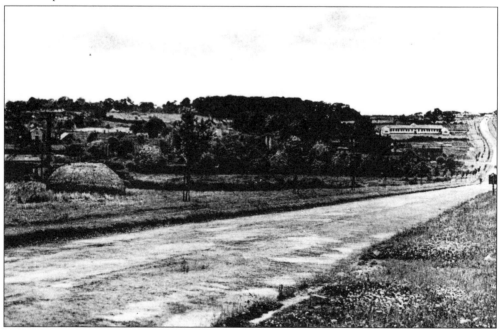

Titchfield by-pass in the 1930s. This road was built in 1931, three-quarters of a mile long it skirted the main part of the village. Costing between £30,000 and £40,000, several cottages in Mill Street were demolished for the route, and thirty per cent of the construction workforce were ex-miners from Wales.

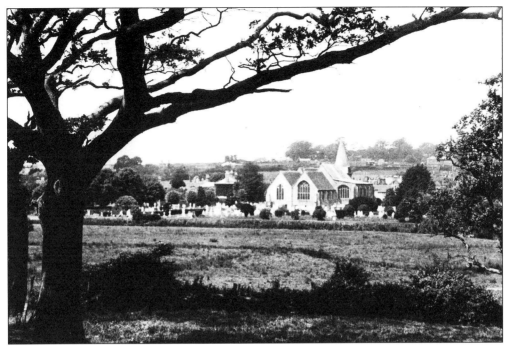

Titchfield village from the east, 1928. This tranquil scene would be difficult to capture today, for yet another by-pass road was built in 1978 to alleviate the amount of traffic from Stubbington passing through the village to reach the A27.

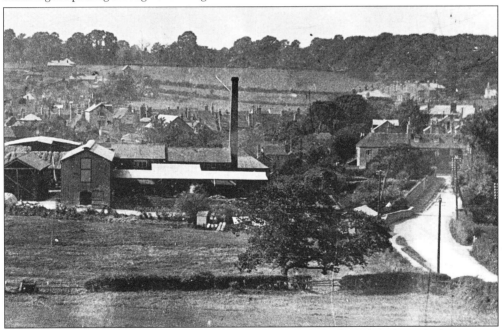

This view of Titchfield shows the original main road on the right before the 1931 by-pass was built, c. 1910. The tall chimney, which was blown down by a gale in 1945, belonged to the tannery run by James Watkins & Sons from 1890 until 1960, although there was a tannery in the village from the early seventeenth century.

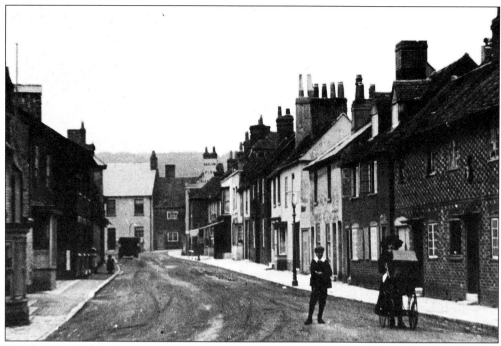

East Street, Titchfield, 1906. This view, looking west, has not changed a great deal over the past ninety years as far as the buildings are concerned, but like many of today's roads it suffers from the presence of cars and the subsequent parking problems they bring.

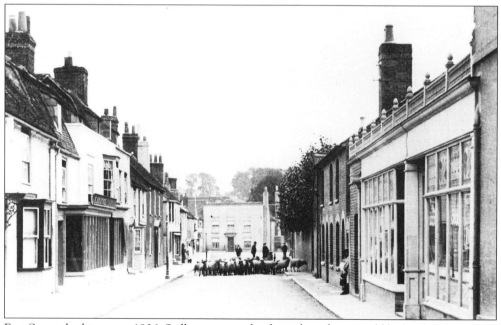

East Street, looking east, 1906. Sadly, gone are the days when sheep could be herded through it.

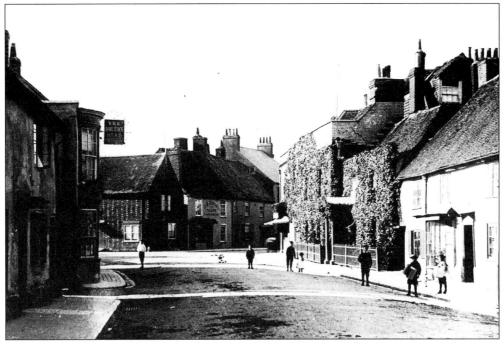

The High Street, Titchfield, 1905. Looking down to where High Street meets East Street, Mr Bungey's tailoring shop may be seen near the Southampton Hill corner, and the Queen's Head inn is on the extreme left.

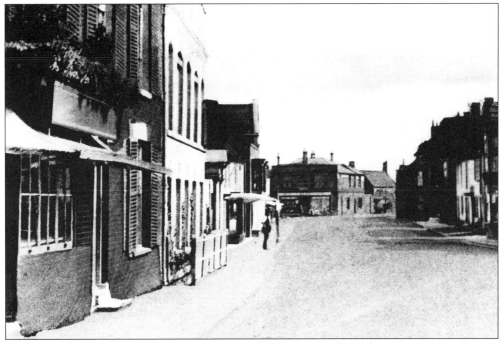

High Street, viewed from the East Street corner looking towards the Square, with the Queen's Head inn on the right, 1906.

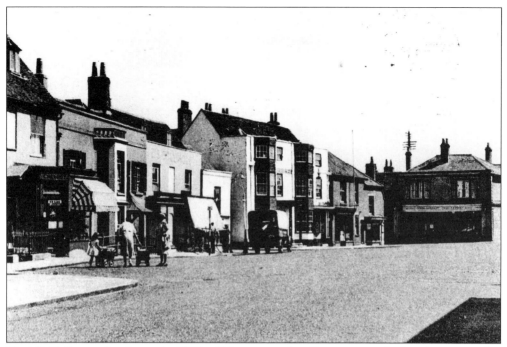

Titchfield Square in the early 1950s. Taken near the Congregational church corner, this photograph features several of the small shops flourishing then, including the family drapers store of Collihole's, which closed in 1982.

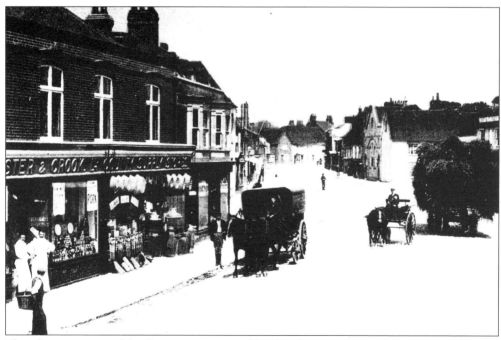

This charming view of the Square was captured by the photographer F.G.O. Stuart, with not a motor vehicle to be seen, 1906. The popular grocery emporium of Lankester & Crook is on the left.

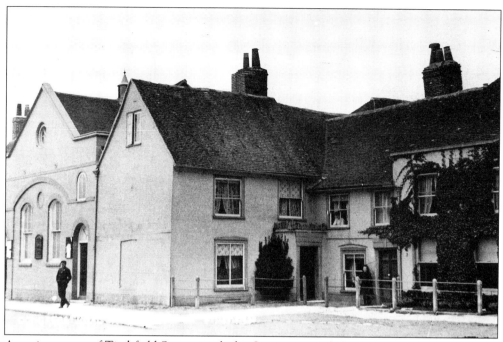

A quaint corner of Titchfield Square, with the Congregational church to the left, *c.* 1906. The buildings on the right are now employed as the Earl of Southampton's Day Rooms for the elderly people of the village.

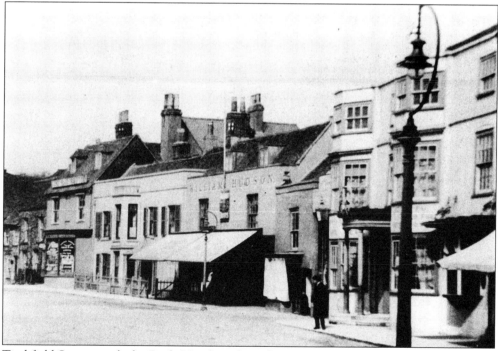

Titchfield Square, with the Bugle Hotel on the right, *c.* 1905. Although it has been known as the Square for over 200 years, villagers were baffled in 1995 when Fareham Council declared that there was no such name, for officially it was the High Street.

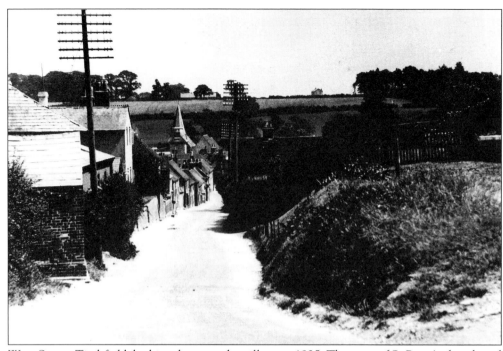

West Street, Titchfield, looking down on the village, *c.* 1925. The spire of St Peter's church and the backcloth of the hill provides some idea of the pleasant valley that the village lies in.

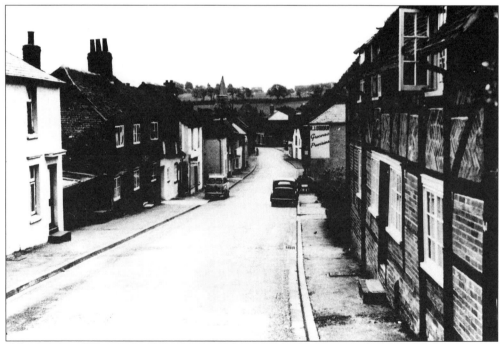

A later view of West Street from the same direction as the previous photograph. This is one of the author's favourite routes in to the village at Christmas time, for almost every house displays an illuminated tree outside, providing a fairyland of twinkling lights.

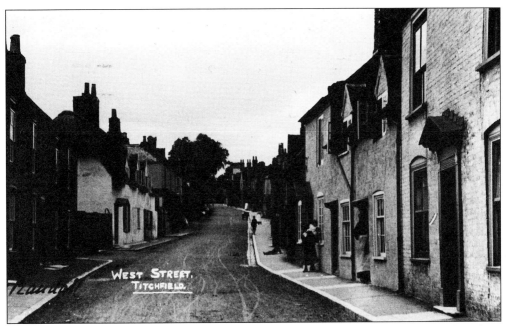

Looking up West Street from the village, *c.* 1905. Many of the houses in this street date from the fifteenth and sixteenth century, but thatched roofs have been replaced by tiles.

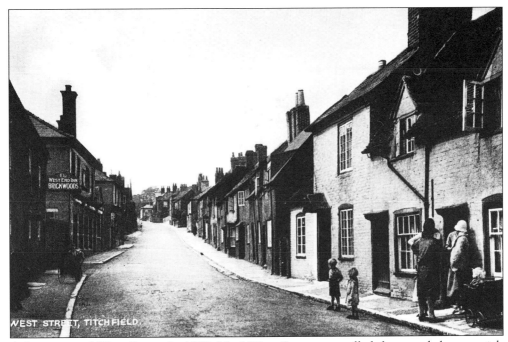

A later view of West Street. In 1937, No.4 West Street was pulled down and the materials carefully removed to be rebuilt at Bramshott, near Liphook. Built around 1550, a murder is reputed to have taken place in the house at one time.

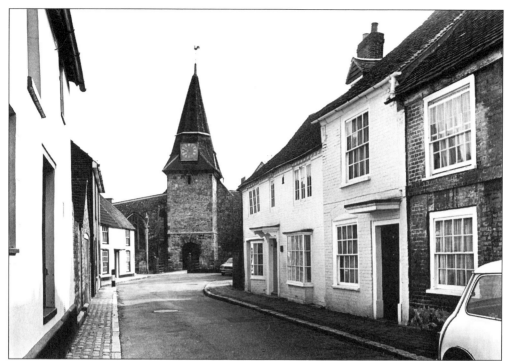

Church Street, Titchfield, from the Square, 1979. Apart from the modern presence of the car, this street has hardly changed in hundreds of years.

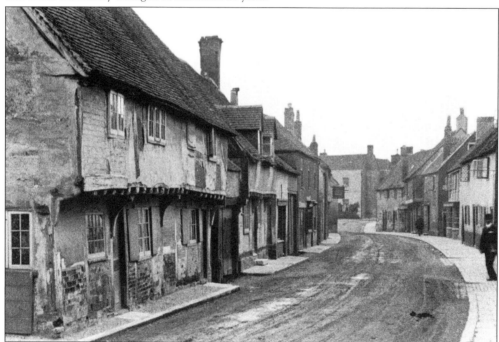

South Street, Titchfield, *c.* 1906. Another thoroughfare that has changed little since Shakespeare's time, although the surface of the road has naturally been improved over the years.

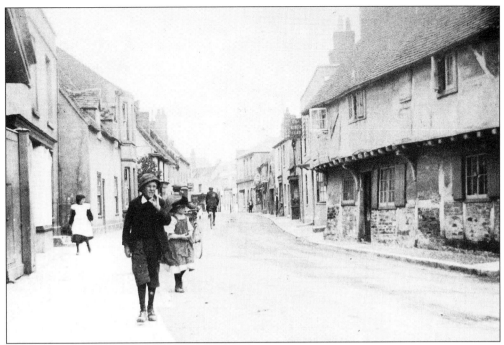

South Street, *c.* 1912. The King's Head public house can just be seen on the right of the street. A closer view of this pub may be seen in the 'Time Gentlemen, Please' section of this book.

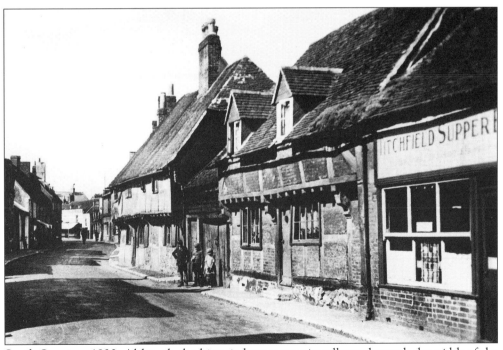

South Street, *c.* 1930. Although the historic houses are virtually unchanged, the width of the road has been the subject of contention over the years, and traffic-pinching points placed in 1995 have proved to be unpopular with the motorists.

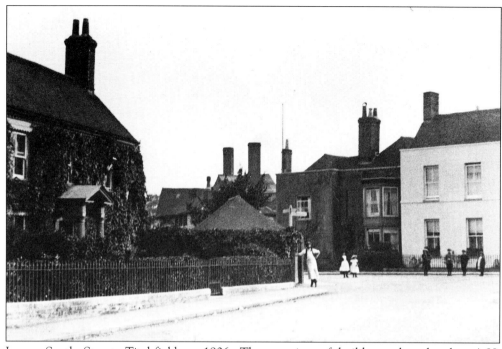

Lower South Street, Titchfield, *c.* 1906. The premises of builder and undertaker A.H. Freemantle are on the left, a family concern that was established in 1856.

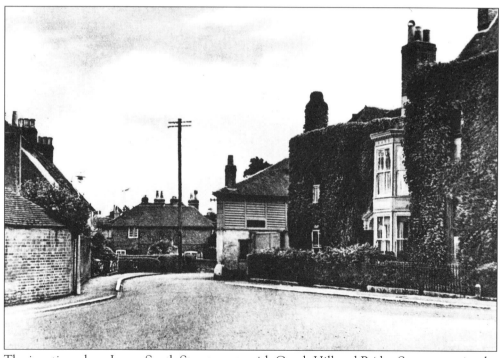

The junction where Lower South Street meets with Coach Hill and Bridge Street opposite the Coach and Horses, *c.* 1950.

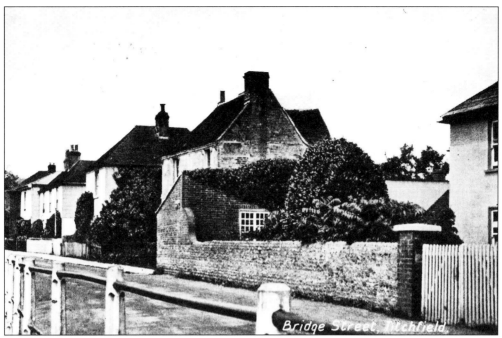

Bridge Street, Titchfield, *c.* 1906. This view, taken from the bridge, has not changed a great deal, the old cottages have been lovingly restored and maintained.

The Weighbridge, Bridge Street. This historic piece of industrial architecture may be seen standing at the entrance to former Titchfield Gasworks, the gas depot was closed in 1951 and the gasholder demolished.

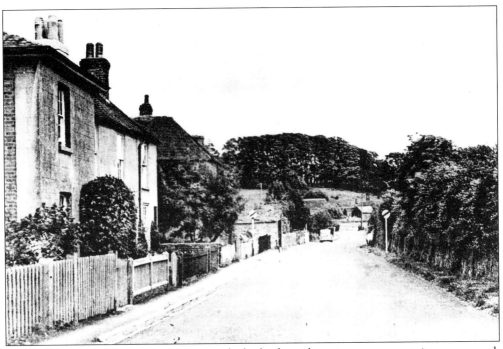

Bridge Street, *c*. 1950. Looking east towards the bridge, where in more recent times a car park has been provided for those embarking on the pleasant riverside walk to Hill Head.

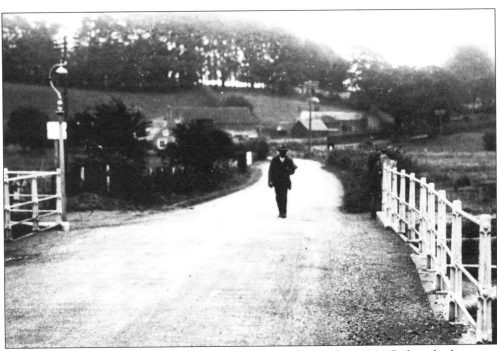

Hollam Hill looking towards Stubbington from the bridge in the 1920s. Before the by-passes were constructed this was a very busy road linking the two villages.

Southampton Hill, Titchfield, 1912. It is hard to imagine now that this was once the main route to Southampton, but it was prior to the village by-pass being built in the 1930s.

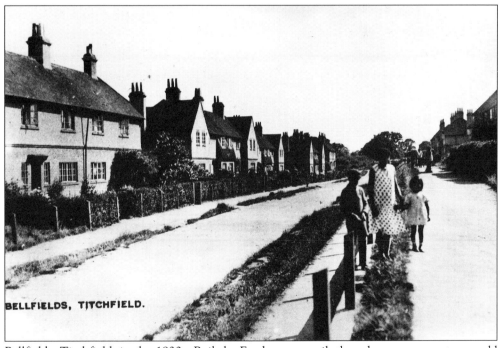

BELLFIELDS, TITCHFIELD.

Bellfields, Titchfield, in the 1930s. Built by Fareham council, these houses were not very old when this photograph was taken.

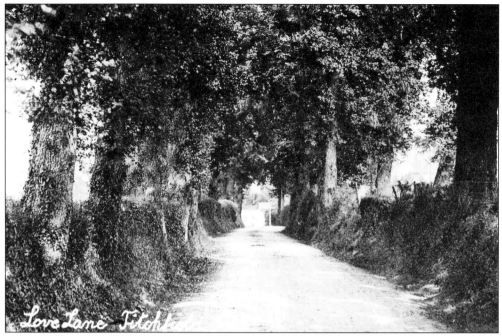

Love Lane, Titchfield, 1910. This idyllic leafy lane and its name may present something of a puzzle for some residents, who for several generations have known it as Ranvilles Lane.

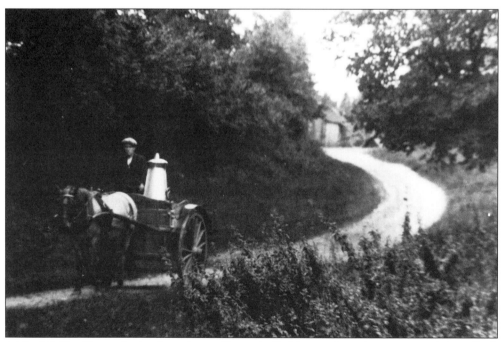

A Titchfield milkman in the days when milk was ladled from a churn into customer's jugs. Back in the 1840s there was a Titchfield milk lady who used to walk through the village leading a cow, from which she dispensed instant fresh milk.

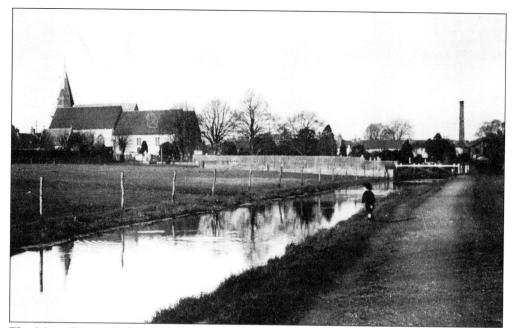

The Meon River, Titchfield, 1912. In earlier times Titchfield was a thriving seaport, but its prosperity declined after the Third Earl of Southampton had the estuary closed at Hill Head in 1611 to reclaim land. He had a canal constructed, but this has not been used by barges since the mid-1800s.

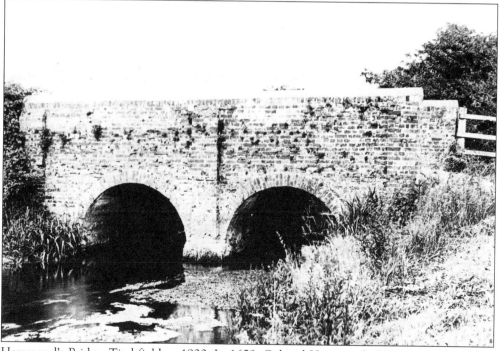

Hammond's Bridge, Titchfield, c. 1920. In 1659, Colonel Hammond, Governor of the Isle of Wight, crossed this bridge on his way to Place House to arrest King Charles I, who had taken refuge there.

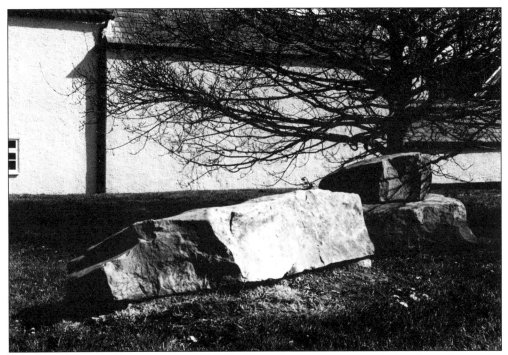

The Sarsen Stones, West Street, Titchfield. These three giant stones, dating from the pre-ice age and millions of years old were unearthed at nearby Kites Croft in the 1980s by a developer, who generously had them transported to the above site in 1989.

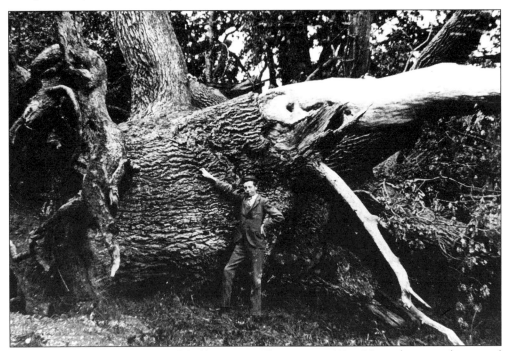

The Old Oak, Place House, Titchfield, c. 1912. This corner of East Hampshire was devastated by 'The Great Storm of 1987', but the author cannot recall seeing a fallen tree this big.

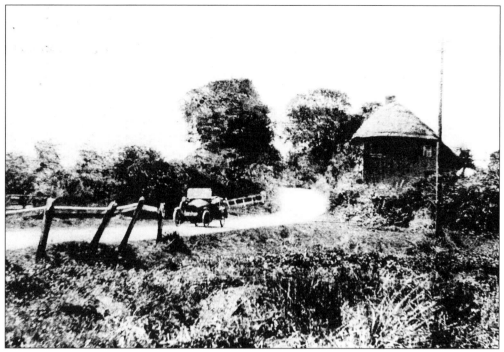

Stubbington Lane, *c.* 1914. Referred to as Stubbington Street on early maps, this road is the coastal link between Stubbington and Lee-on-the-Solent. When this photograph was taken, Victoria Cottage was one of only a few buildings in the lane.

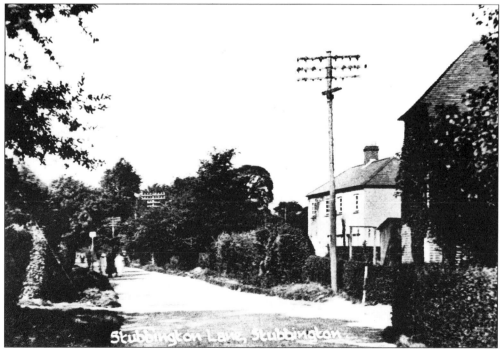

By the 1930s, Stubbington Lane was developing, although this picture still has some measure of rural charm, contrasting with the busy traffic scene it presents today.

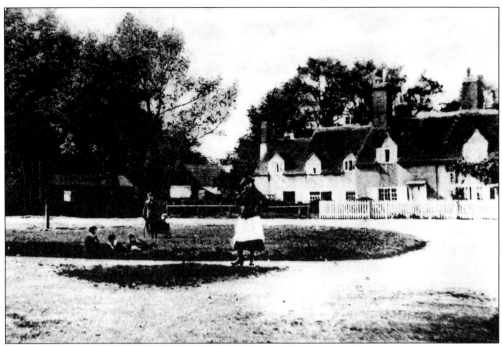

Stubbington Green, *c.* 1910. Captured in the days when children could play in the streets, this view of the Green is looking across to Park Lane where Forbuoys newsagent is sited in the 1990s.

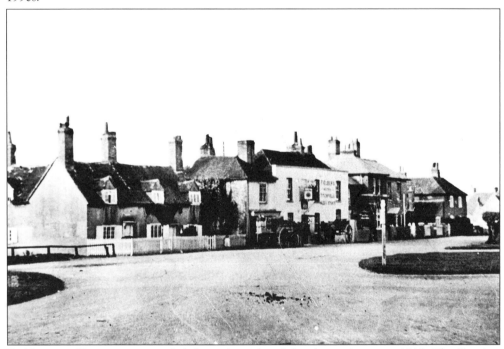

Stubbington Green, in a view slightly to the right of the above picture, *c.* 1910. The Sun inn may be seen next to the ancient cottages with carts outside, their drivers no doubt inside partaking of alcoholic refreshment.

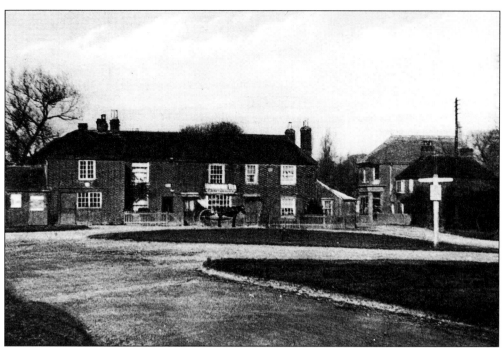

Still turning to the right, this row facing the Green included a blacksmith's forge and a grocer's shop. The opening at the left of this block led into Titchfield Road, while Burnt House Lane is to the right of it.

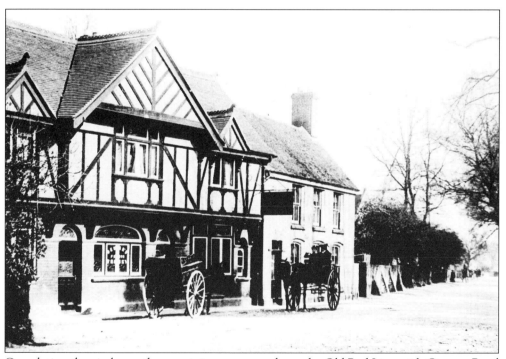

Completing the circle, on the remaining corner we have the Old Red Lion with Gosport Road to the right of it at the junction with Stubbington Lane.

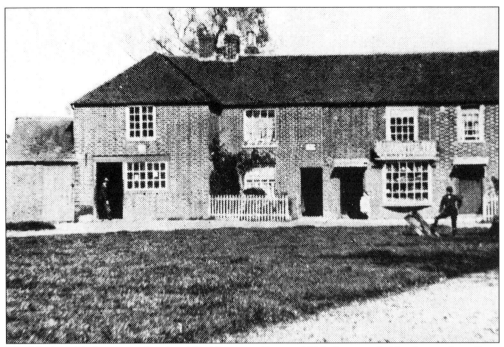

The blackmith's forge, north side of Stubbington Green, 1908. Surrounded by farms, the village blacksmith was an important member of the community in times past. Stubbington had at least two, the other forge was nearby in Titchfield Road.

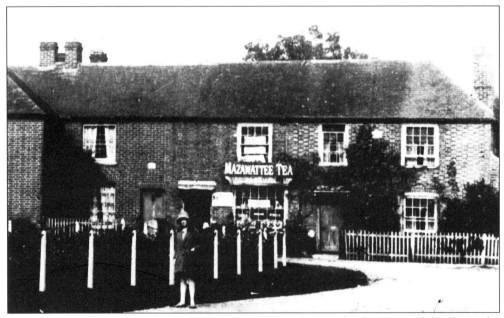

The quaint village grocer's shop, which was run for many years by the Binstead family, in the 1930s. Sadly, this row, which included the forge, shop and cottages, was destroyed on 5 June 1944, when a doodle-bug (a V1 flying bomb) fell on it.

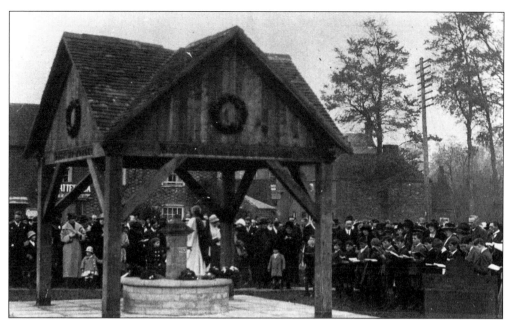

After the First World War, the Green at Stubbington gained one of its most notable landmarks, the wooden war memorial that still graces the village centre. Built by local builder Arthur Tribbeck, the memorial was erected over the old village pump which became redundant when piped water was introduced in the 1920s. The two photographs show the memorial being officially dedicated on 12 November 1922.

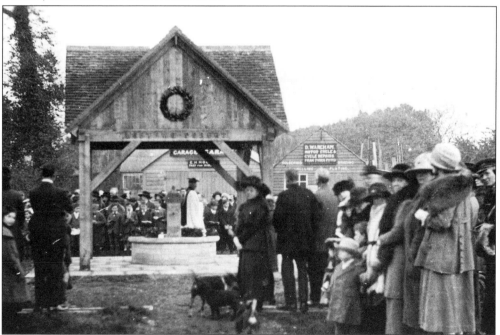

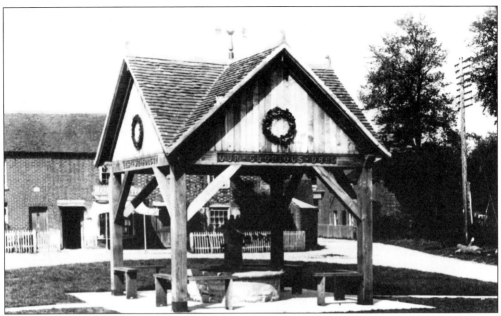

The war memorial in the 1920s, not long after it was dedicated. Over seventy years on its original concept is still honoured every November for Remembrance Sunday.

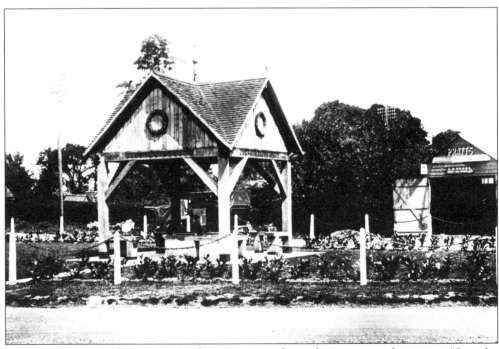

The memorial in the late 1920s. By this time it was deemed necessary to fence it in. Note the lack of buildings to the left of Ernie Moore's garage, this is now occupied by the block that comprises the post office and Barclay's bank.

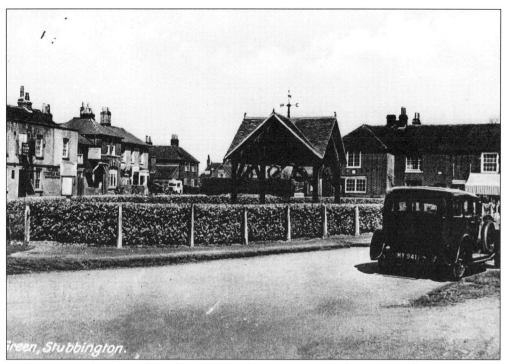

Looking across the Green from the garage in the 1930s, wreaths hanging on the war memorial indicate that this photograph was taken around the November time.

Another view of the garage on the Green, showing how the space to the left of it has been filled by shops, in the 1930s.

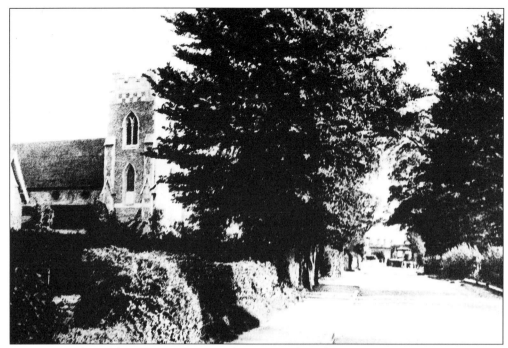

Gosport Road, Stubbington, *c.* 1950. Looking from the village towards Peel Common, this picture was taken before the surrounding area was developed and the volume of traffic increased considerably.

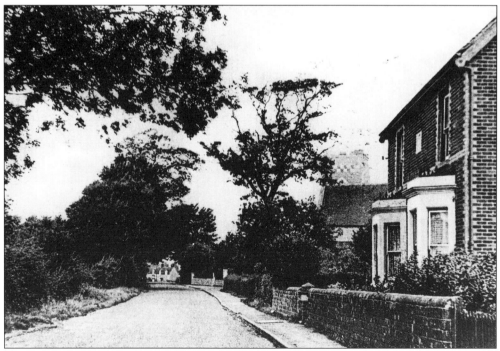

Gosport Road, Stubbington, around the same period as the picture above, but taken from the opposite direction looking towards the village.

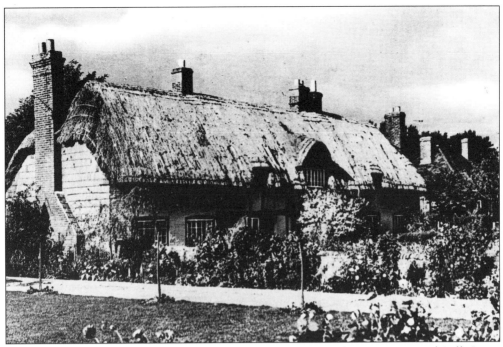

Vine Cottages, Stubbington. Standing near the corner of Stubbington Lane and Bells Lane. Although these picturesque old cottages were demolished in the 1960s, they are still fondly remembered by many villagers.

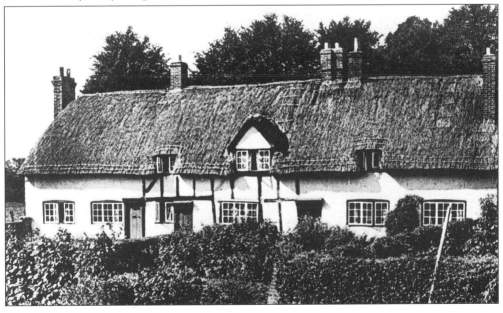

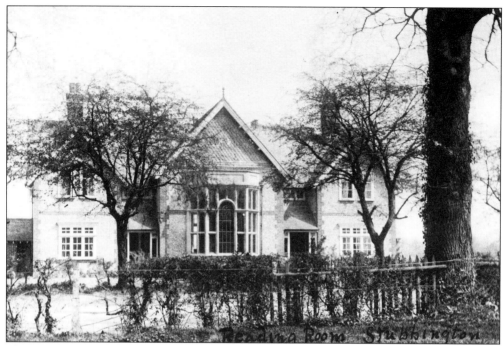

The Reading Room, Stubbington, 1905. Sited in Gosport Road, this picture was taken two years after it opened in 1903. It was built at the expense of Montague Foster of Stubbington House, the facilities included billiards.

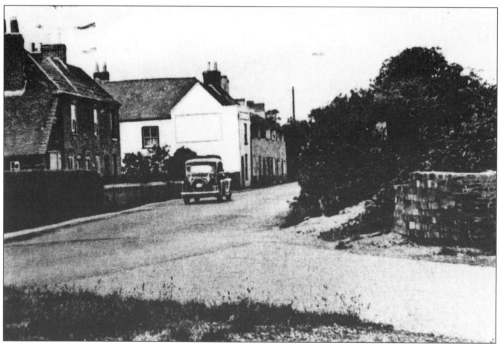

Titchfield Road, Stubbington, from the corner of Mays Lane, c. 1950. The white building just beyond the car is the former Blacksmith's Arms pub, which was closed in 1923 by Brickwood's brewery to remain as a private residence until 1970, when it was demolished.

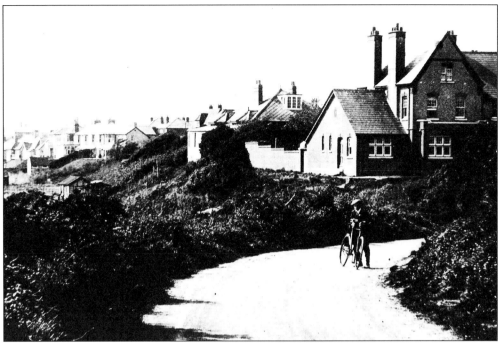

A lone cyclist poses in Salterns Road, Hill Head, c. 1930. This coastal road between Lee-on-the-Solent and Hill Head has managed to retain its winding country lane charm.

Hill Head Road, Hill Head, looking east in the 1950s. The Osborne View hotel can be seen on the right of the picture.

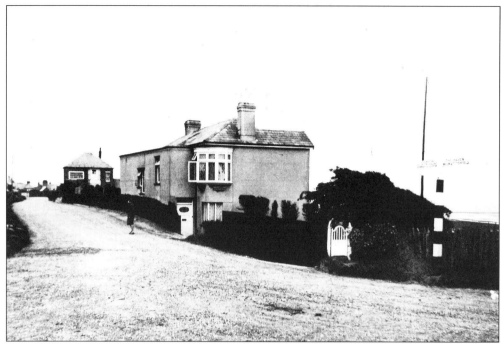

Hill Head Road, Hill Head, at its junction with Cliff Road and Old Street in the 1940s. A short steep lane at the right of the picture leads down to the beach.

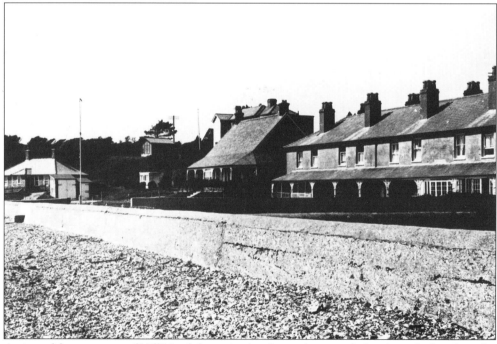

A view of the same area of Hill Head shown in the above photograph, but from the beach in the 1930s. The lane mentioned above is to the extreme left.

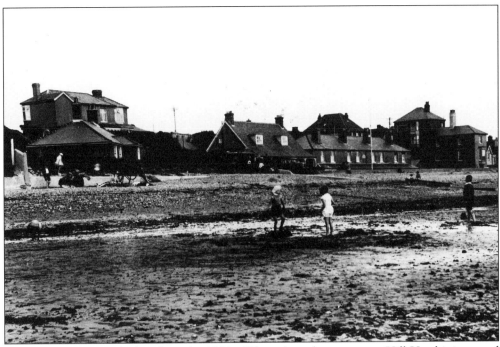

Children playing on the beach in the 1930s. When the tide goes out at Hill Head it is a good place for finding cockles. The rear of the Osborne View pub is on the extreme left.

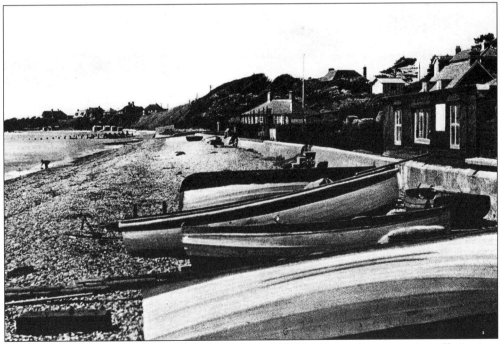

Reed's boat house, Hill Head, 1938. Sixty years on, Hill Head gives the impression of being in a time warp, still imparting a great feeling of nostalgia for childhood days long past.

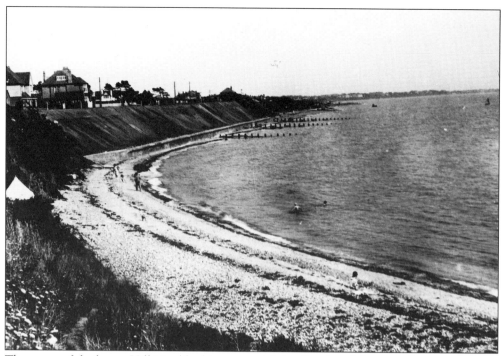

The sweep of the bay at Hill Head looking east, with hardly a beach hut in sight.

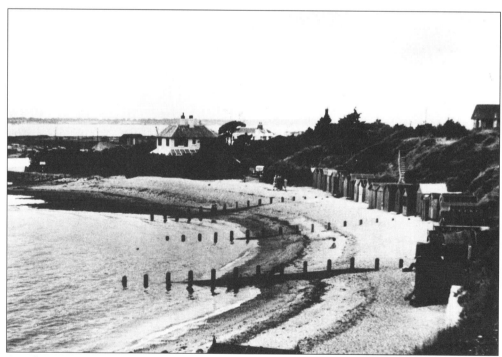

Another view from the cliffs, looking west. The house at the end of the beach has long since been demolished to make way for a clubhouse for the Hill Head sailing club.

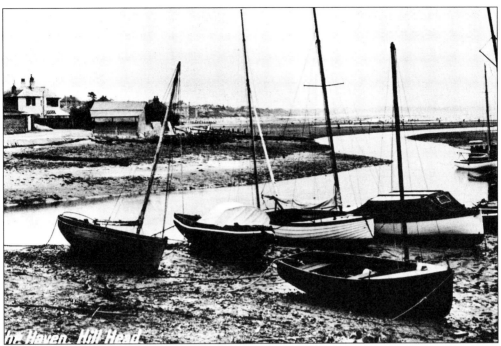

The Haven, Hill Head, late 1940s. This picture shows the inlet leading into the small harbour, the house on the extreme left is the one previously mentioned that was replaced by the sailing club.

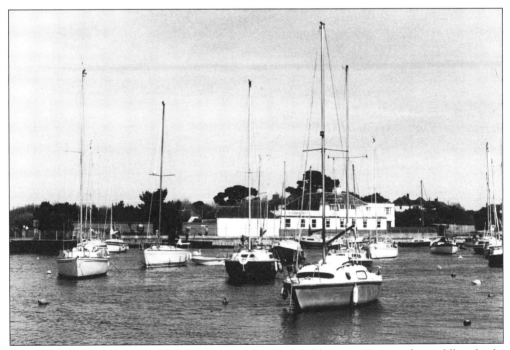

A view of the Haven in the 1990s. Adjoining the Titchfield Nature Reserve for waddling birds, wildfowl and rare breeding birds, this is one of the most untouched spots on the South coast.

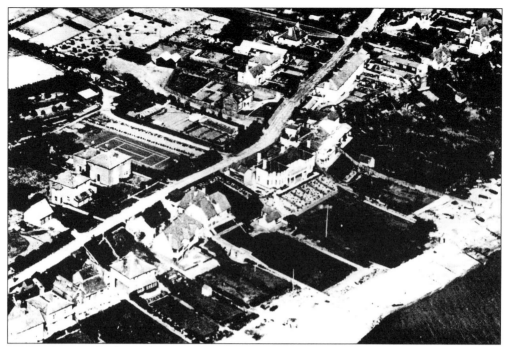

An aerial view of Hill Head in the 1930s. As a marker, the coast guard cottages can be seen on the right of the road near the top of the picture.

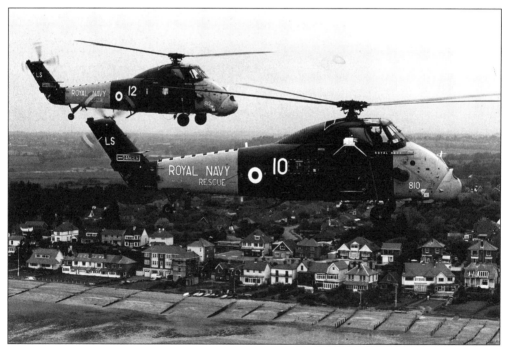

The Royal Navy Rescue helicopters passing Hill Head front in 1979. This splendid shot was captured by the photographic unit of *HMS Daedalus* at Lee-on-the-Solent, which sadly closed in 1996.

Two

Back to the Land

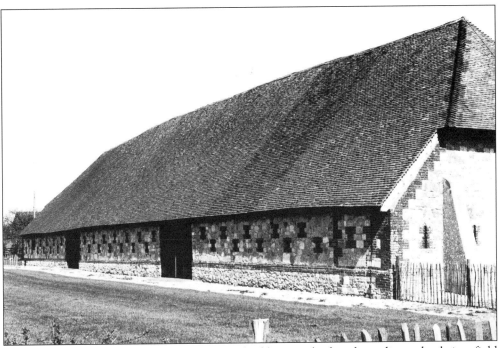

The Tithe Barn, Titchfield. This magnificent building can be found standing sedately in a field close to Titchfield Abbey, and is thought to date from the fifteenth century. Spanning some 157 feet long and 46 feet wide, it was left to decay for some years, but in the 1980s it was expertly restored to serve currently as a farm produce centre. It is quite mind-boggling when one considers that the roof contains over 70,000 tiles.

A GROUP OF HEIFERS.

Winners of 1st, 2nd, 3rd and Reserve Prizes, Fareham Show, 1922, and 1st and 3rd Prizes Havant Show, 1922.

The Property of F. A. HOLLIDAY, Esq., Rome Farm, Stubbington, near Fareham.

FED ON THORLEY'S CAKE.

In this advertisement, the makers of Thorley's cake were quick off the mark to proclaim that the success of Farmer Holliday of Rome Farm, Stubbington, at the Fareham show was due to the wonders of their product, 1922.

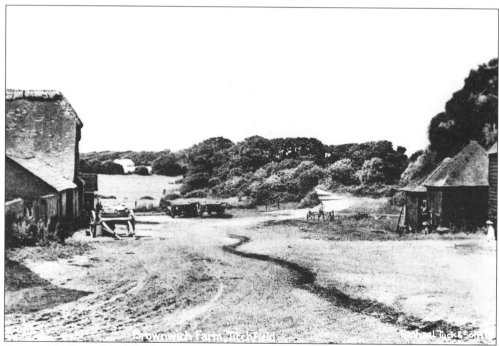

Brownwich Farm, Titchfield sometime around 1947. Both Titchfield and Stubbington had strong farming communities in times past, and although many of those once lush fields have been replaced by bricks and mortar, there are still several farms flourishing in the area.

Carron Row Farm, Titchfield, 1982. This 300 year old listed farm barn was converted into a museum of farming history by the Ireland family as a memorial to farmer Jim Ireland.

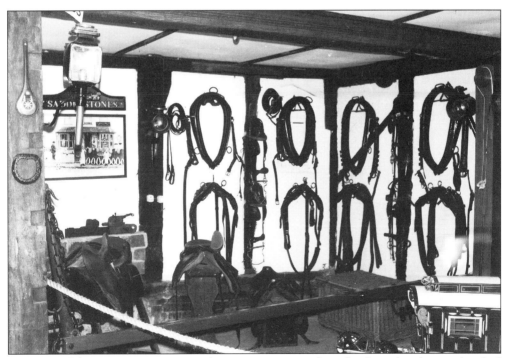

A section of the Carron Row museum featuring equipment from the days when horses ploughed the fields. Sadly, this unique local museum was forced to close in 1987, with the vast collection of farming implements being auctioned off.

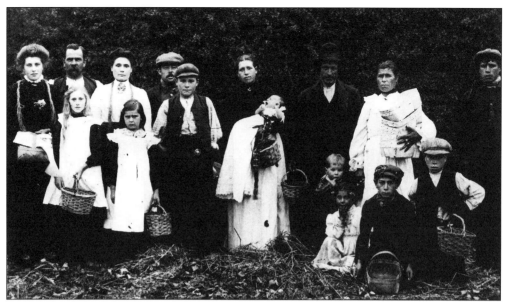

In the early years of this century, Titchfield and the surrounding area was one of the biggest strawberry producing districts in the country. Gypsy pickers, such as those shown above, invaded the area in large numbers during the season.

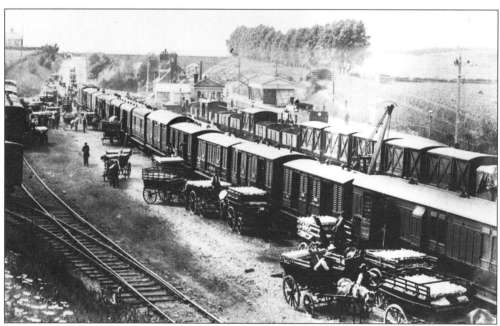

Swanwick railway station, c. 1912. For a few weeks of the year this small station was one of the busiest in the country, with local strawberries being dispatched to every corner of the British Isles.

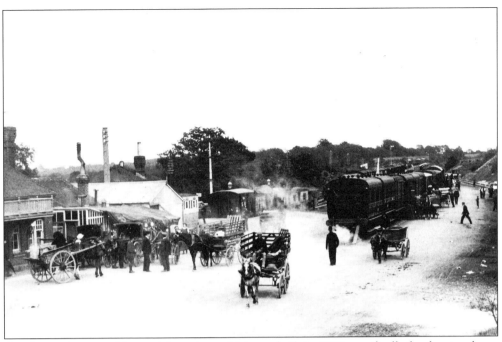

Another early view of Swanwick station, which was built in 1888 specifically for the strawberry trade. The chief factor for the growing of the fruit in the area was the enclosing of Titchfield Common in 1866 when the land was parcelled into plots.

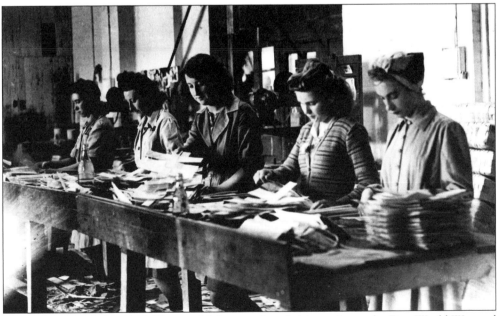

The Basket Factory in 1946. This establishment, founded just prior to the First World War and sited near the station, played an important role in the local industry. Sadly, it closed after strawberry fields were swallowed for housing in the 1960s and 70s.

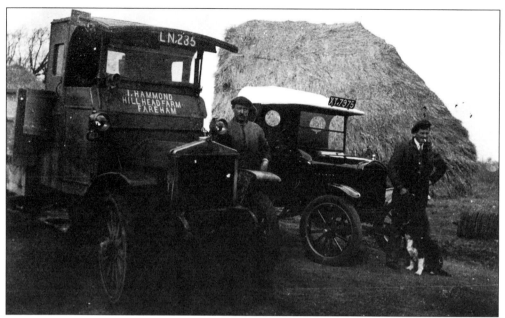

Issac Hammond's Farm, Hill Head, in the 1920s. Specialising in fruit and flower growing, Hammond's provided work for many local people.

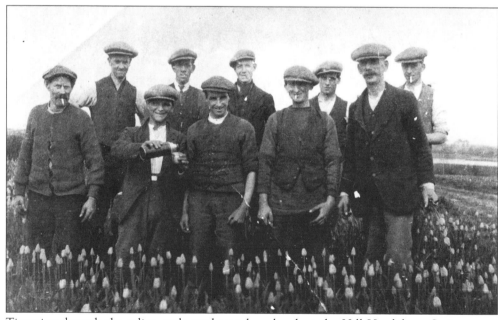

Tiptoeing through the tulips, male workers take a break at the Hill Head farm. Spring was a glorious time, with acres of tulips in the fields surrounding Stubbington.

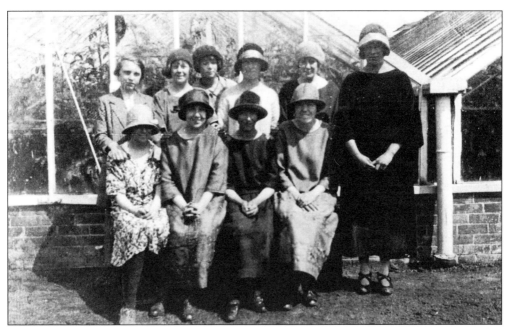

Lady members of Hammond's workforce in the 1920s. Hammond's had an extensive garden centre off Stubbington Lane, but it succumbed to housing development in the 1980s.

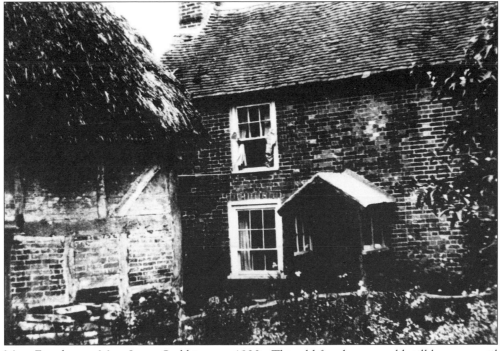

Mays Farmhouse, Mays Lane, Stubbington, 1930s. This old farmhouse could still be seen until the 1950s, it was sited directly opposite the Thatch in Mays Lane.

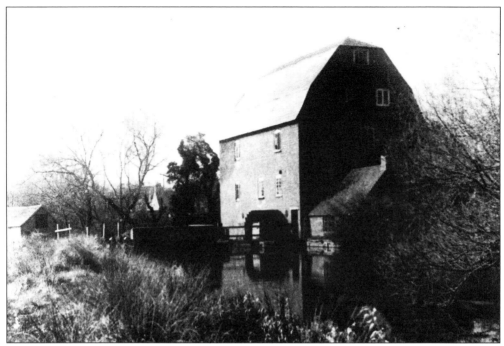

Titchfield Water Mill. A mill was mentioned on this site in the Domesday Book, but the building shown was erected in 1834. Milling was discontinued in the 1950s and the mill now serves as a centre for garden and agricultural requisites.

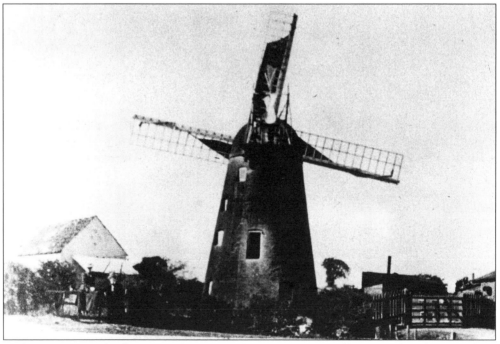

Peel Common windmill, 1905. After it ceased operating as a mill, it served as the 'Windmill inn' beer house before it was demolished in 1926. The kennels of the Gosport & Fareham Beagles was once housed nearby.

Three

Going to Church in Stubbington and Titchfield

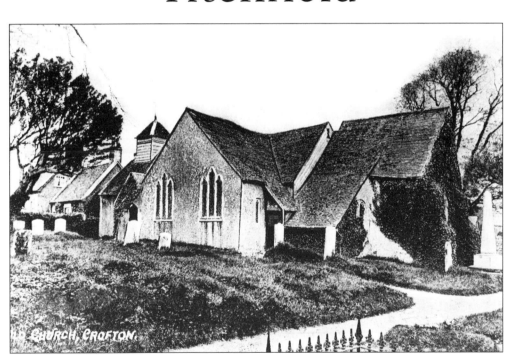

The Old Church, Crofton, 1906. Standing serenely back from the main Stubbington to Titchfield road, this ancient church was mentioned in the Domesday Book and dates back to 878 AD. The church was noted by Samuel Pepys on his journey from Portsmouth to Southampton in 1662, describing it as a 'little churchyard where the gravestones are accustomed to be sowed with sage'. This historic church, is lovingly maintained by the Friends of Crofton Old Church, every summer a 'strawberry fayre' is held on the Green in front to raise funds.

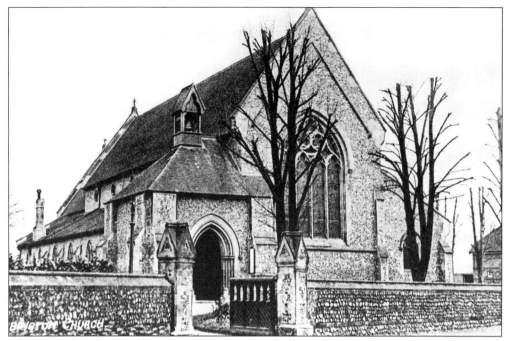

The parish church of Holy Rood, Stubbington. By the latter half of the nineteenth century the area was beginning to expand and the Old Church was too small to accommodate its parishioners, so Holy Rood was erected in Gosport Road in 1878.

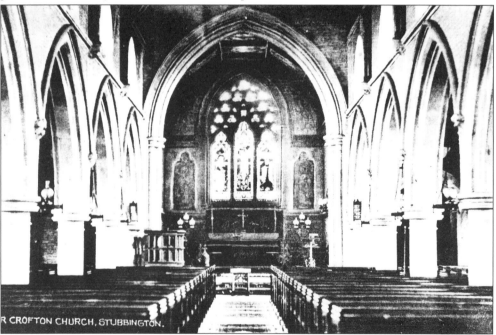

Interior of Holy Rood, c. 1930. The land for the church site was given by Montague Foster, and the building was completed through donations from Sir Frederick Sykes and Lord of the Manor Henry Delme. The Delme east window seen in this picture was destroyed by enemy bombing in 1944.

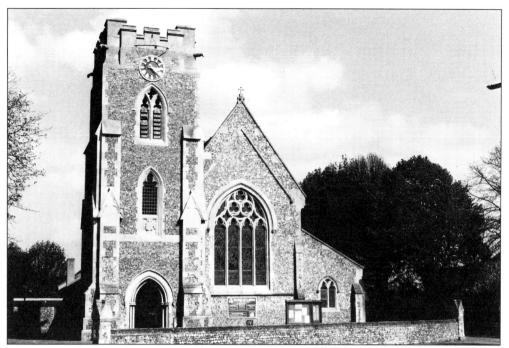

Holy Rood church, Stubbington Road. Compare this photograph with the 1908 picture opposite, we see the tower which was added in 1928 as a war memorial for the 'Old Boys' of Stubbington House School.

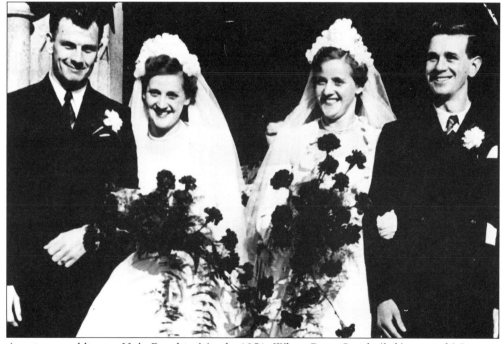

A unique wedding at Holy Rood in March, 1951. When Peter Smith (left) married Margaret Miller, and Tony Tubb (right) married her twin sister Olive, it was the first double wedding at Stubbington within living memory.

A clock was added to the tower of Holy Rood church in 1935 to mark King George V's silver jubilee. It stopped in 1989 to remain stuck on 5.47 for seven years, when after attempts by parishioners to mend it, a firm of clock repairers from Derby were called in to fix and renovate it in 1996 at a cost of £3,000. Following additional work in 1997 the chimes were heard once again after twenty-two years of silence.

The Catholic church of the Immaculate Conception, Bells Lane, Stubbington. Although the church hall was completed in 1975, the final phase of the building programme came to fruition with the first mass in the new church taking place on 4 December 1985.

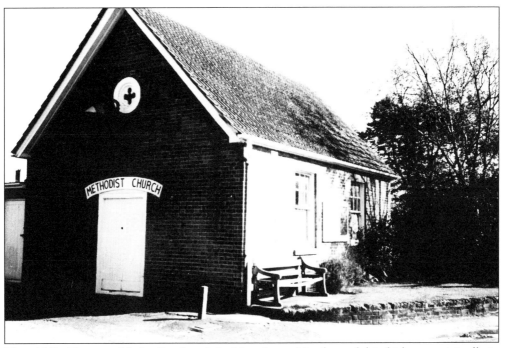

The old Stubbington Methodist church in Mays Lane. Members of this faith met originally in houses in the early nineteenth century, until a chapel was built on this site around 1857. The Methodist church has always played an important part in Stubbington village life.

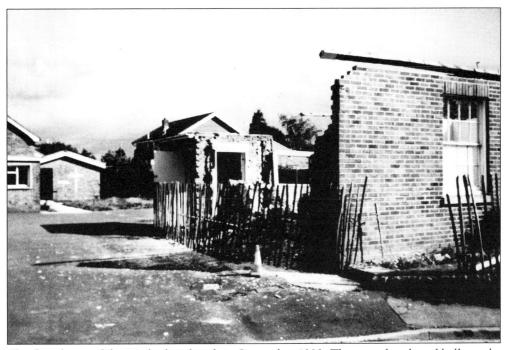

The demolition of the Methodist church in September 1992. The new church and hall may be seen in the background, the hall is a popular venue for the Stubbington WI weekly markets.

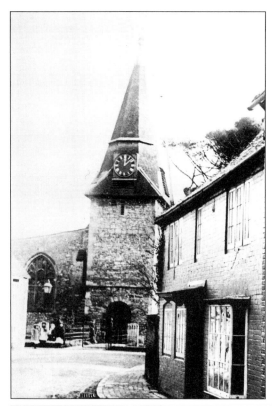

St Peter's church, Titchfield, *c.* 1908. This beautiful old church is the jewel in Titchfield's crown, standing serene and dignified through so many phases of history. The lower portion of the tower and the south-west corner of the nave is Saxon work, probably the oldest piece of ecclesiastical masonry remaining in Hampshire. The grand Norman doorway is a fine example from the latter part of the twelfth century.

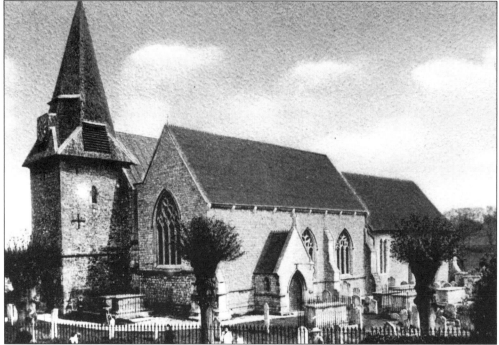

St Peter's church, Titchfield, *c.* 1905. The tower was raised twice before the graceful shingled spire was added in the fifteenth century, and a clock added to the tower in 1887.

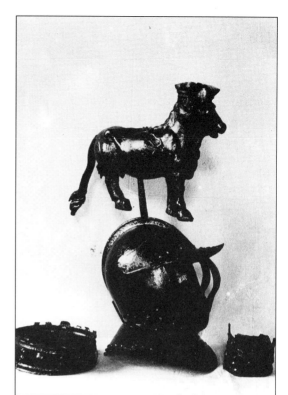

Described as one of our national monuments, the tomb of the Earls of Southampton may be seen inside St Peter's, the remains of the family in lead coffins below the crypt are reputed to have been pickled in honey. This photograph taken sometime around 1910, shows the mortuary helmet and crowns of the Second Earl of Southampton.

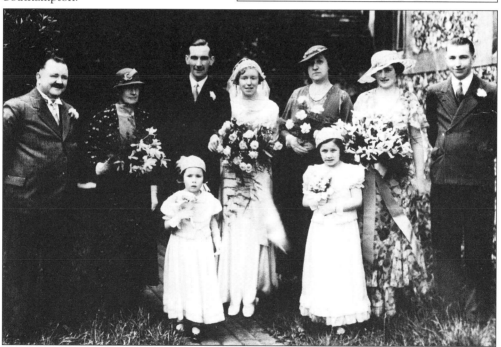

The wedding of Henry Hart and Gwendoline St John in 1935. Mr Herbert St John, on the extreme left, was the well-known Titchfield baker in the High Street. After the wedding at St Peter's, this group picture was taken outside the Parish Rooms.

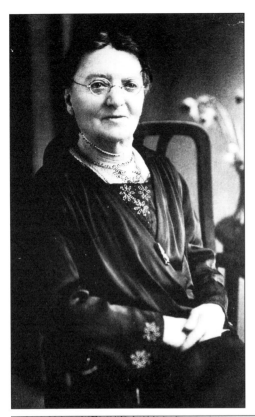

Eleanor Hardiman, who, with her husband Samuel, founded the Peel Common Mission on 28 May 1900. On this memorable Sunday afternoon Eleanor played hymns on an old harmonium that they had carried out onto the common, and very soon a crowd gathered.

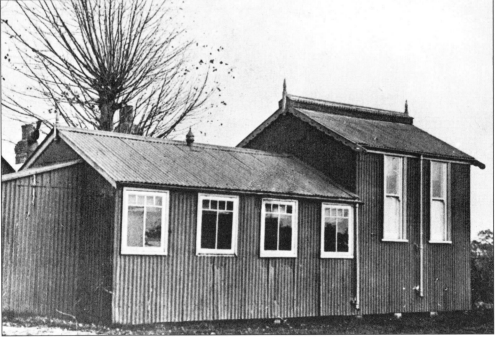

Peel Common Mission church, 1906. The number of adult and children worshippers grew until they were able to erect this wood and corrugated iron building on the common in 1902.

Samuel Hardiman, and his wife Eleanor hoped that one day they would have a more permanent church building. Their dream was realised in 1926. Her work was done and Eleanor died in 1929 and Samuel followed her in 1936, they are both buried at Crofton Old Church.

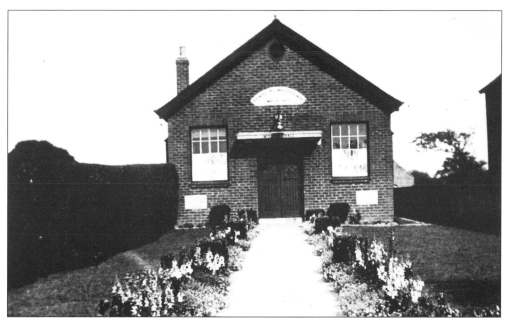

The Peel Common Evangelical church, 1930. Through the hard work and dedication of Eleanor, Samuel and their flock, this church was opened in October 1926 and still graces the site.

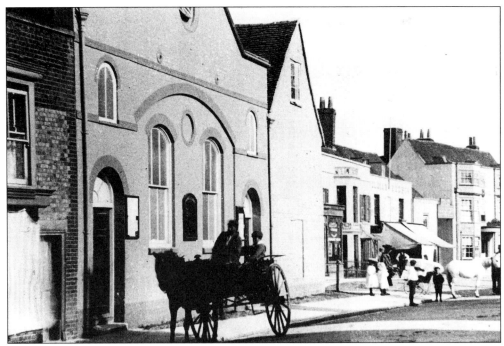

The Congregational church, Titchfield, 1906. An independent chapel was established here in 1789, although the facade of this structure has been the subject of alterations over the years.

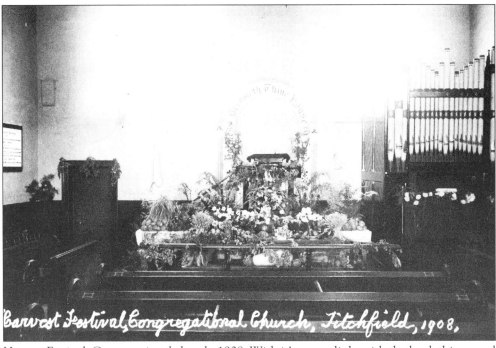

Harvest Festival, Congregational church, 1908. With it's strong links with the land, this annual event has always been part of Titchfield village life. This place of worship still flourishes under the Evangelical banner.

Four
At Your Service

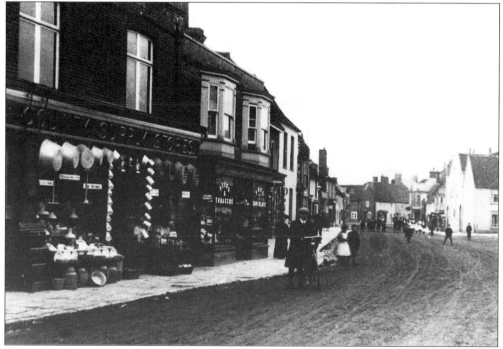

Lankester & Crook's general stores, Titchfield Square, *c.* 1907. This revered emporium was a delight to enter, the unique aroma derived from a mixture of ham, coffee, apple, onions, firewood and paraffin, and there was always a cane chair for the customer to rest on. At one time, the store had two vans delivering around the area, the driver's being Charlie Frampton and Fred Rowe, but sadly Lankester & Crook ceased trading in the 1960s.

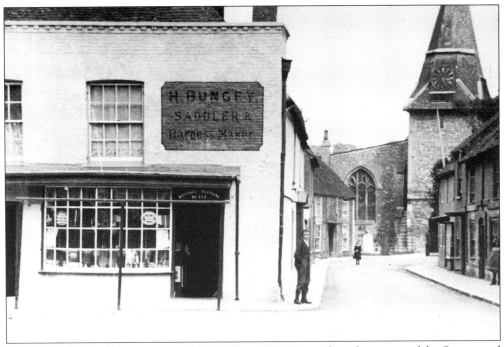

Bungey's saddle and harness store, Titchfield, c. 1907. Situated on the corner of the Square and Church Street, Mr Bungey enjoyed a good custom from the many farms and large houses in the area.

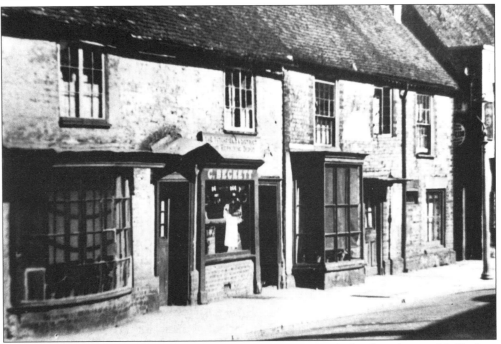

Beckett's boot and shoe repair shop in the High Street, c. 1930. As hard-working as Mr Beckett was, he was not as industrious as an earlier Titchfield shoemaker named Dare, for in 1809 his wife gave birth to their twelfth child, all born within a period of nine years and ten months.

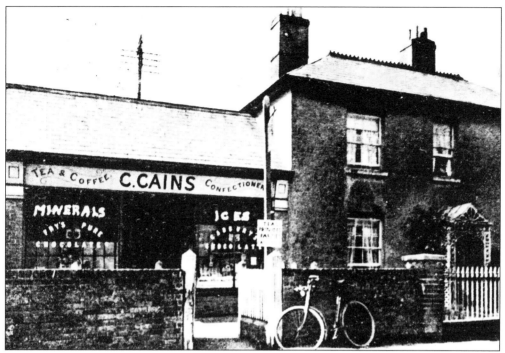

Cain's grocery and sweet shop at the Green, Stubbington, c. 1912. The village telephone exchange was situated behind these premises, and the first public call-box was sited there.

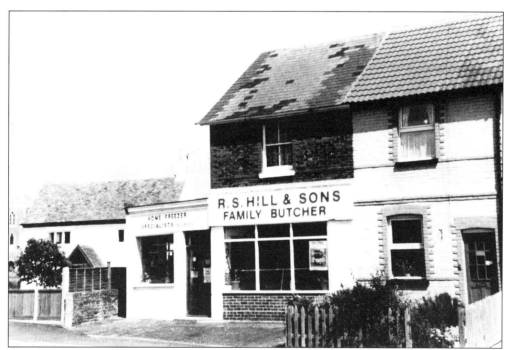

Hill's butcher's shop has flourished in Stubbington Lane for some years, but older villagers will remember when this shop was run by the Watts brothers.

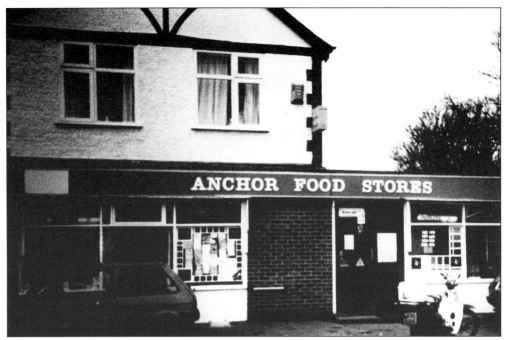

The Anchor Food Stores, Titchfield Road, Stubbington. This popular convenience store flourished at a time when the road was considerably quieter, but closed in 1989 to be converted to a private house.

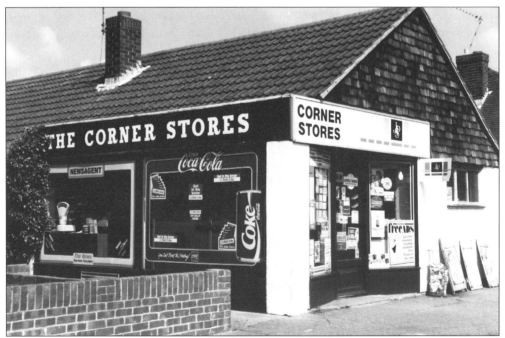

The Corner Stores on the corner of Mays Lane and Green Road, Stubbington. Another much-missed corner shop which closed in 1995, it also has been converted to a domestic dwelling and there is no sign that a store ever existed.

The Coast Guard Station, Hill Head, 1904. Providing another kind of service, back in the 1830s, the coast guards were almost the only residents at Hill Head, their presence required chiefly to prevent the smuggling that was rife in the area in times past. The lower picture was taken at the rear on the station sometime around 1905.

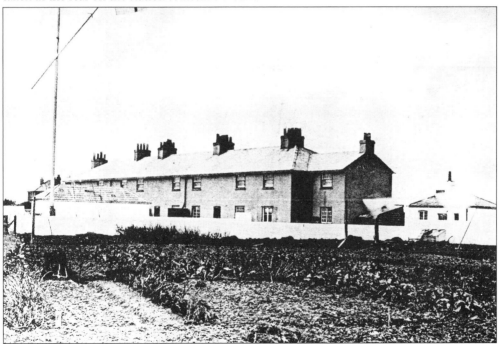

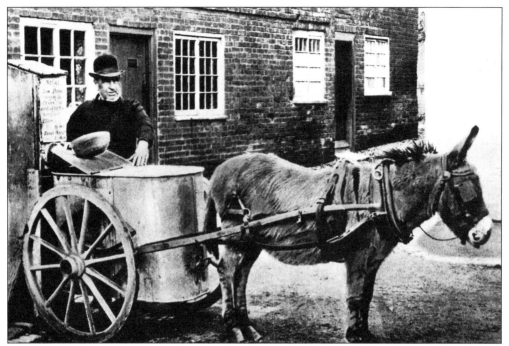

The Titchfield water works in 1906. The village pump played an important role in village life in earlier times, Titchfield's was sited on the corner of East Street near its junction with the High Street.

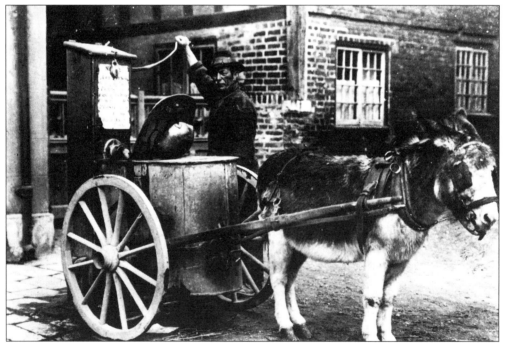

This view of the water carrier, taken from the same spot as the above picture a few years later, is interesting by the fact that in 1908 a cottage behind the pump was demolished and replaced by a mock-Tudor entrance arch for the Old Lodge.

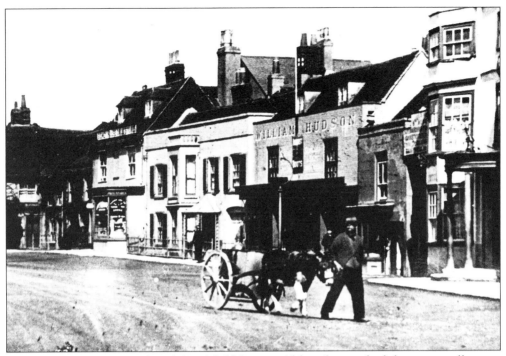

The water carrier passing though Titchfield Square. Although some had their own wells, most local folk were glad to take up the service provided by the carrier, paying him a farthing for a two-gallon bucket of water.

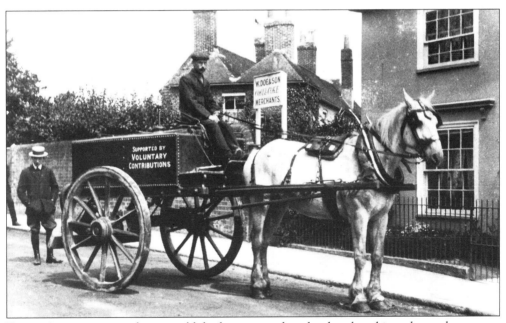

You can't stop progress, the poor old donkey was made redundant by a bigger horse-drawn cart, which in turn became surplus to requirements around 1923 when water mains were introduced into the village.

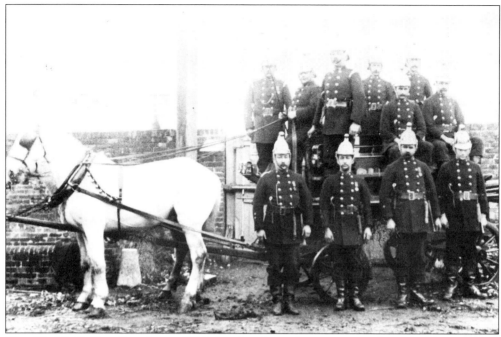

The Titchfield Fire Brigade, *c.* 1910. In the days when many roofs in Stubbington and Titchfield were thatched, and more people had coal fires, the brigade were kept fairly busy. Mr Bungey was the fire chief from 1901 to 1936.

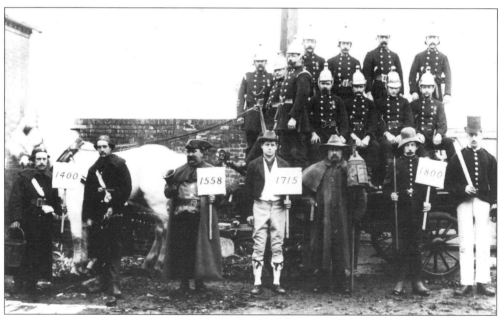

'Fire fighting through the ages 1400 to 1910', as depicted by the Titchfield brigade at a carnival. There was always a great deal of rivalry between the Titchfield and Fareham brigade's in beating each other to the scene of the blaze first.

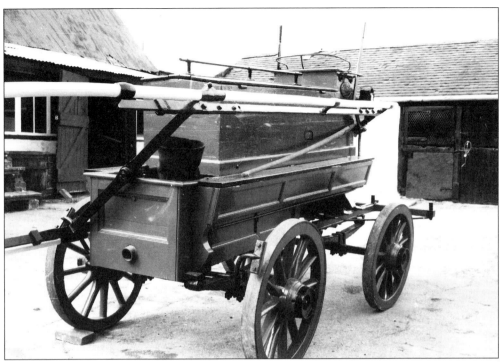

The old Titchfield fire brigade tender. At one time the tender was kept at St Peter's church and churchwardens were expected to turn out to fires.

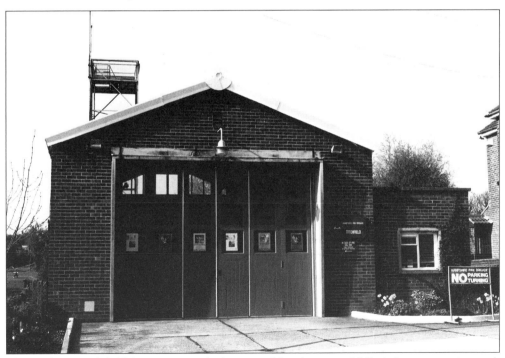

The modern Titchfield fire station at the bottom of Southampton Hill. A fierce campaign took place in 1995 to prevent this busy station from being axed.

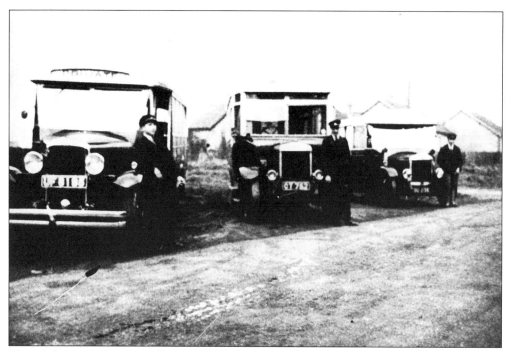

Moore's bus and charabanc fleet, *c*. 1930. Operating from Crofton Lane, Stubbington, Ernie Moore ran a bus service to Lee and Fareham as well as being the proprietor of the village garage on the Green.

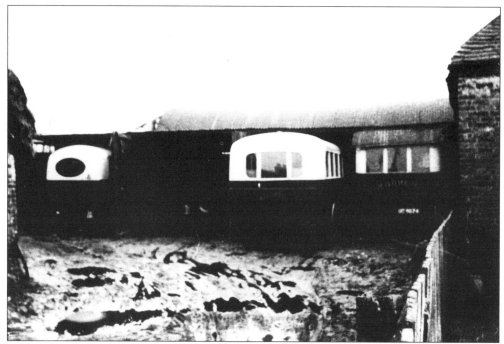

Looking more like a muddy farmyard, this was Moore's bus depot, which was actually an old barn off Crofton Lane. Ernie Moore had a son, Cyril, who was destined to find fame in the sporting world, as featured in the 'Leisure and Pleasure' section of this book.

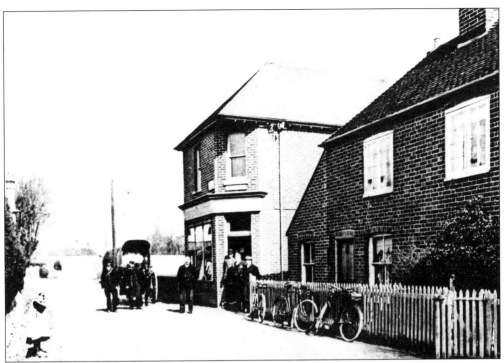

Stubbington post office, *c.* 1905. Situated on the corner of the Green, just inside Burnt House Lane, it was run for many years by the Binstead family.

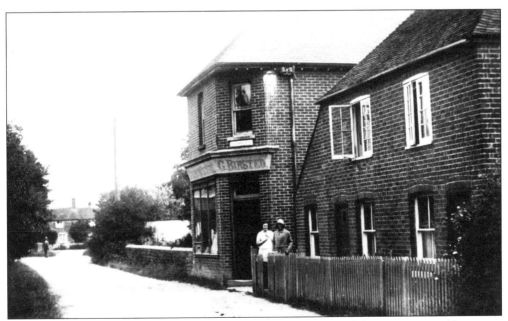

Stubbington post office in the 1930s. With all the outlying farms, delivering post could prove to be a marathon task, but in the 1930s the Hants & Dorset Bus Company introduced mail boxes fixed to the rear of their buses to link the village.

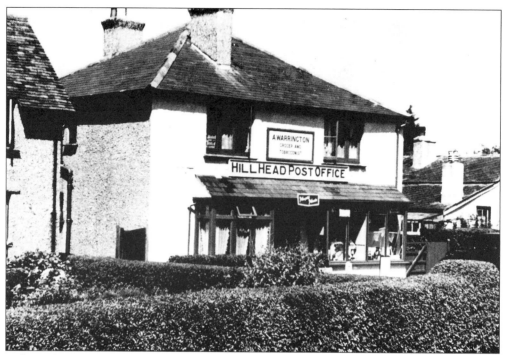

Hill Head Post Office. Opened originally in 1913, this office still provides a valuable service for residents, but extensions over the years to transform it into a mini-supermarket have changed the fascia considerably compared to this picture.

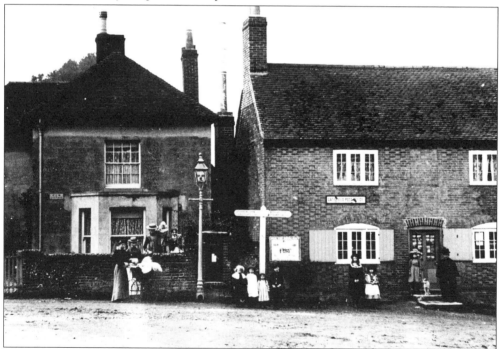

Catisfield Post Office, *c.* 1906. Unlike so many other sub-post offices, it has escaped the postal axe and still serves within the village general stores.

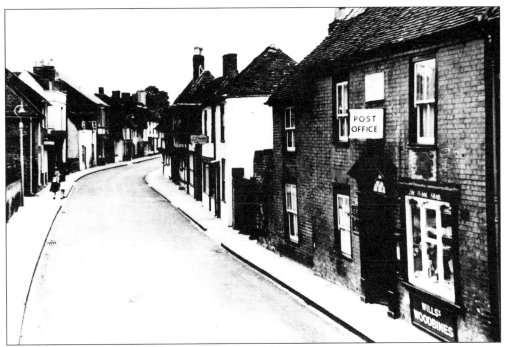

The post office in Titchfield moved quite often, this picture was taken when it was in South Street, on the site of the former 'Red House' public house. It is now a private dwelling named the 'Red House'.

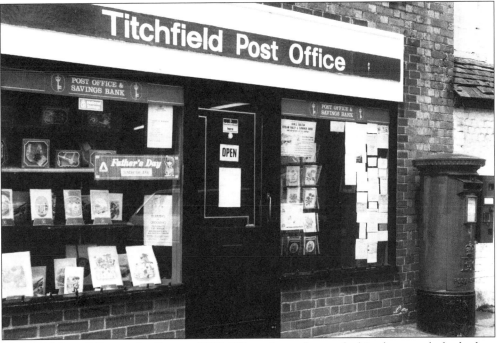

Titchfield Post Office in the Square, 1983. When the author took this photograph, he had no idea that he was capturing history, for within a few years it had moved to the opposite side of the Square and the above photograph is now a betting shop.

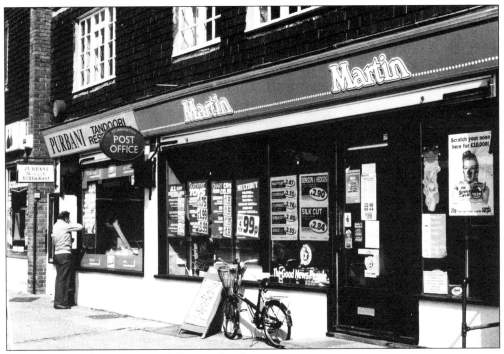

The current Stubbington Post Office on the Green.

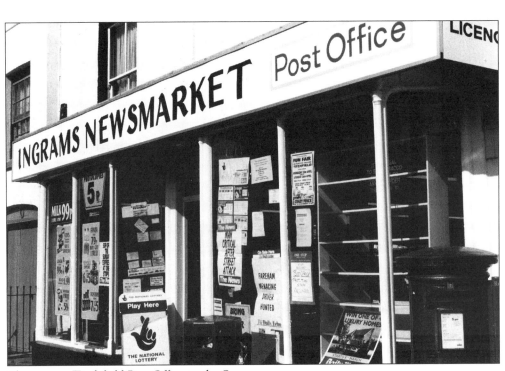

The current Titchfield Post Office in the Square.

Five

Back to School

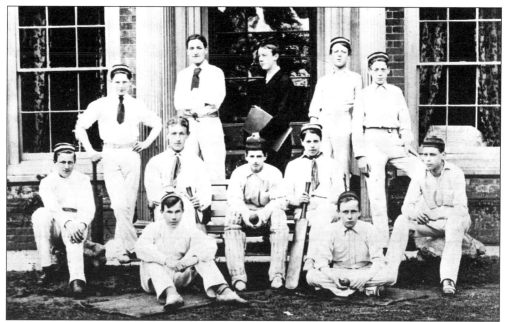

Stubbington House School Cricket XI, *c.* 1900. This noble seat of learning played a big part in
Stubbington life for around 120 years, for in addition to contributing to the prosperity of local
tradesmen it also provided employment for a good number of village folk.

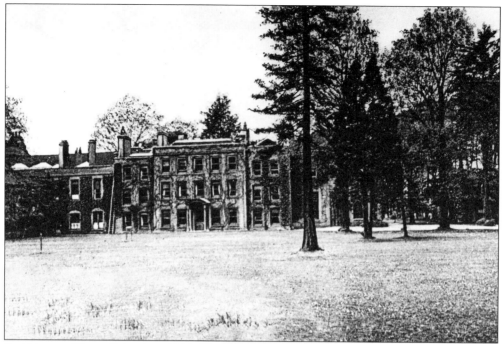

Stubbington House School, *c.* 1916. This fine house, built in the reign of Queen Anne, had several owners before being taken over in 1841 by the Revd William Foster, who with the help of his wife Laura founded an academy for the sons of rich people wishing to enter the Navy.

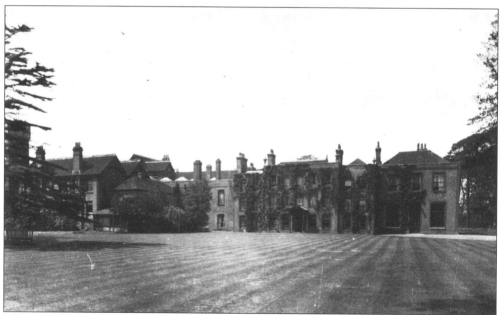

When William Foster died in 1866, his son Montague took over and under his guidance the academy gained a high reputation as a Naval School, in fact it was referred to in some circles as the 'Cradle of the Navy'.

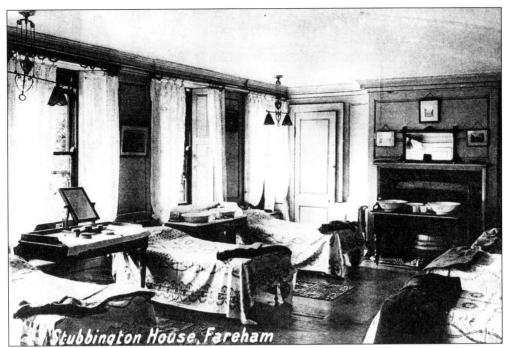

The Green Room, Stubbington House. As befitting their station, accommodation for pupils could be described as comfortable. Famous Old Boy's included Lord Charles Beresford, Sir John Cunningham, Prince Alexander Albert of Battenburg, and Captain Robert Falcon Scott of the Antarctic fame.

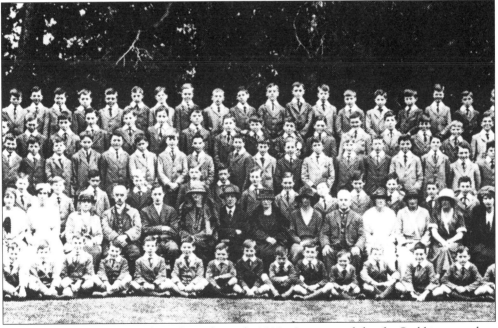

Stubbington House staff and pupils in the early 1920s. It was a sad day for Stubbington when the school moved to Ascot, Surrey, in the early 1960s. Much of the original building has been lost, what remains serves as a community centre.

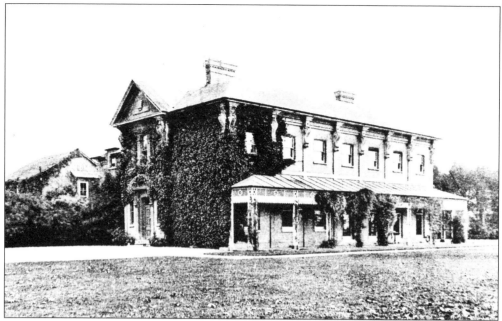

Seafield Engineering College, Hill Head. A fine Victorian mansion that was built for Sir Henry Sykes in 1872, in its heyday the interior decoration and magnificent staircase were reputed to be among the finest in the South of England.

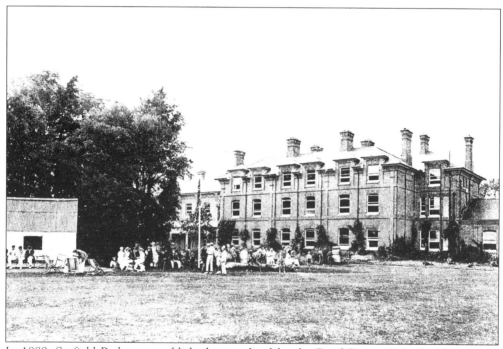

In 1888, Seafield Park was established as a school by the Revd Rupert Pain for 'the sons of noblemen and gentlemen'. Then, in 1903 it changed hands to become a college for training those 'sons' to become engineers.

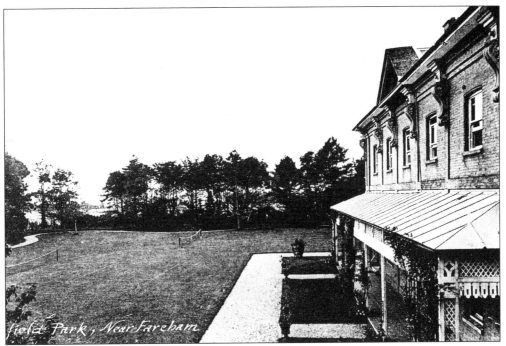

In 1910, Seafield Park became a boys preparatory school, Captain Eyston the famous motor racer was a former pupil. In 1939, the school was evacuated to Devon and it was taken over by the Admiralty as a Signal Training School.

The Lodge to Seafield Park, *c.* 1912. This is still standing in Crofton Lane. The original main house was destroyed by fire in 1948, the remaining buildings serving as the Royal Naval Survival Equipment School until 1989. It is now undergoing development plans.

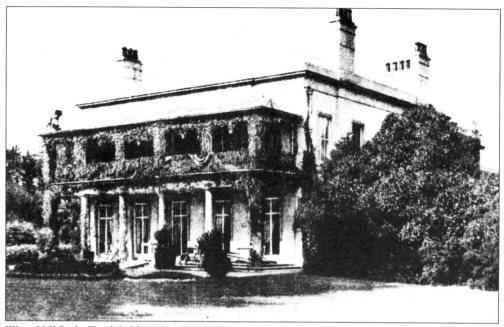

West Hill Park, Titchfield, 1903. This building was erected around 1770 as a hunting lodge, but after a succession of private owners it became a boys preparatory school in 1920.

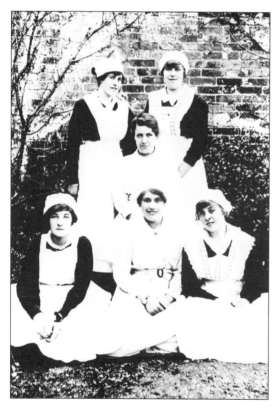

Maids and staff at West Hill Park School, c. 1920. Founded by Charles Ransome on 23 January 1920, it began with eighteen boys, this number included Ransome's son Jimmy, who was later to become the second headmaster. The school has been extended over the years and now boasts over 250 pupils. It is reputed to have a ghost - a coach and four which comes down the main drive and stops by the old stable block.

The old school and school house in West Street, Titchfield. This National school was built in 1830 and was the subject of several extensions until closure in 1933 after the new school near the by-pass was opened. This building is now occupied by Gaylord's antiques.

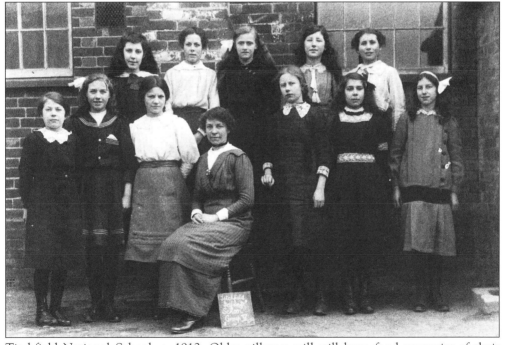

Titchfield National School, *c.* 1912. Older villagers will still have fond memories of their schooldays here, especially in the twenties when Miss Richards was a teacher there. Her mother, Leilah Richards, also taught at Locks Heath school.

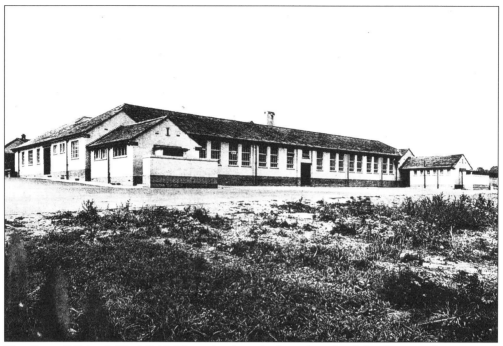

The Council School, Titchfield. This school was built at the side of the then new by-pass road in the early 1930s, to cope with the rising population.

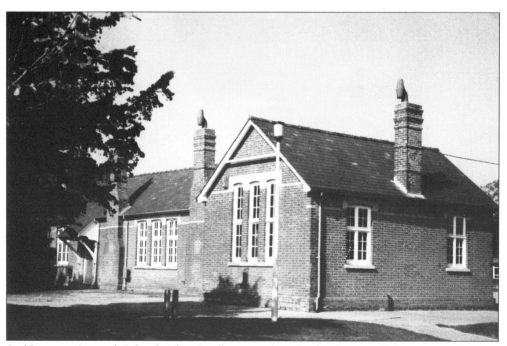

Stubbington Council School. This fondly remembered school can still be seen in Gosport Road, it was built in 1874 to replace an earlier National school that was erected in Titchfield Road in 1854.

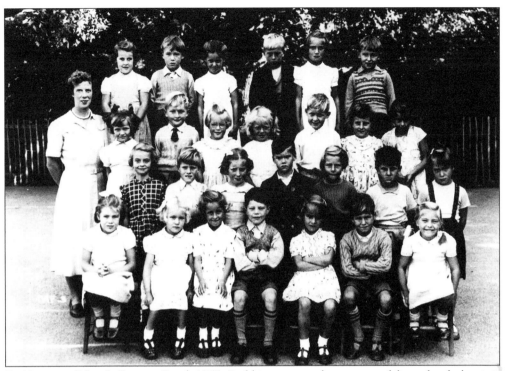

Stubbington School, Gosport Road, 1955. Stubbington now boasts several fine schools, but it is this old school that many villagers will best remember.

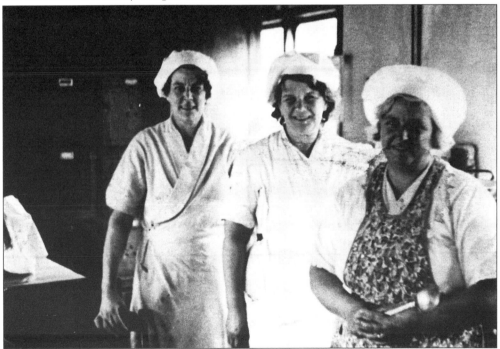

The Backroom Girls, dinner ladies at the Gosport Road School in the early 1950s. Left to right: Mrs Barter, Mrs Tubb and Mrs Smith.

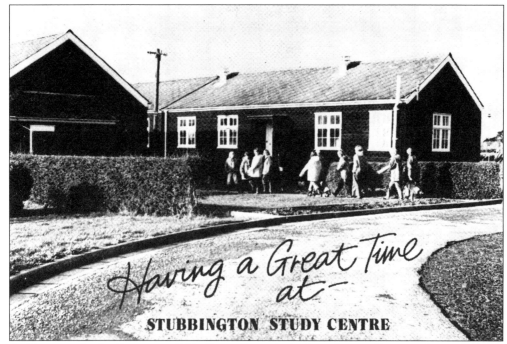

Stubbington Study Centre, c. 1950. Regardless of whether they really were 'having a great time', the youngsters' parents were pleased to receive these cards. The summer camps were first introduced in the 1930s by Southampton Education Committee for families who could not afford a holiday at the seaside for their children. Combined with schoolwork, a nominal charge of five shillings was made for a fortnights stay.

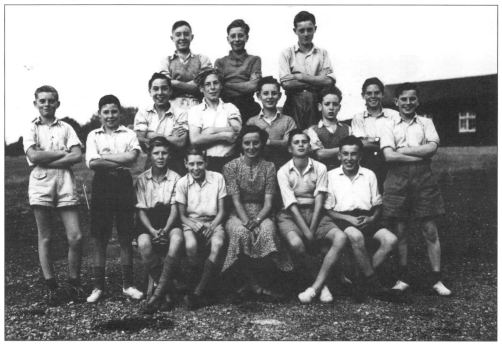

Six
Leisure and Pleasure

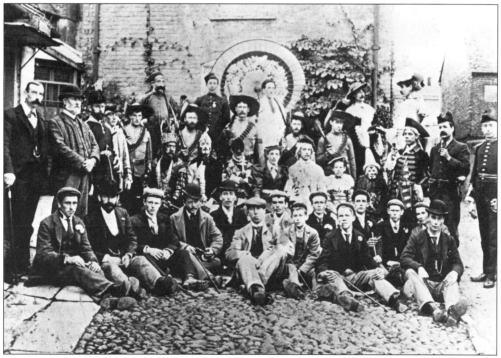

Titchfield Bonfire Boys, 1897. Attracting anything up to 50,000 people, the annual Titchfield carnival is the biggest celebration of its kind in the South of England. Taking place in the October school half-term, it has afternoon and evening processions through the streets.

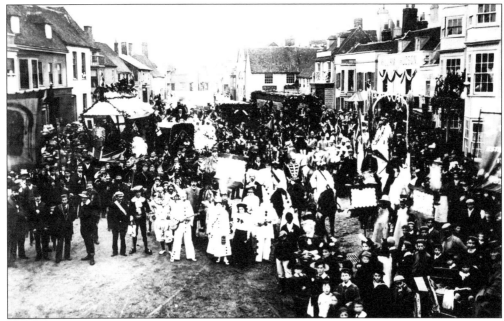

Titchfield carnival, *c.* 1900. The Bonfire Boys were established in 1880, although it had earlier associations connected to the Third Earl of Southampton, who upset the villagers by blocking off the estuary at Hill Head in 1611 and prompting them to protest by parading the Earl's effigy before setting fire to it.

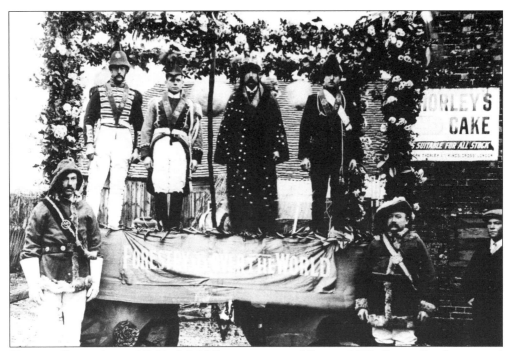

'Forestry all over the world', Titchfield Foresters carnival float, *c.* 1908. Originally, the carnival bonfire was just a tar barrel being burnt in the Square, but by 1894 it developed into a costume parade with a band and torch bearers, ending with the burning of the guy.

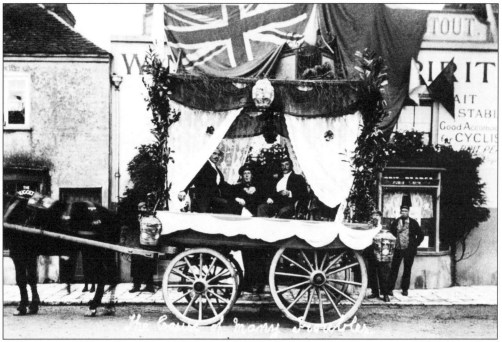

'The cause of many troubles' carnival float in 1907. This picture was taken outside the Wheatsheaf pub in East Street, a very popular venue during carnival time.

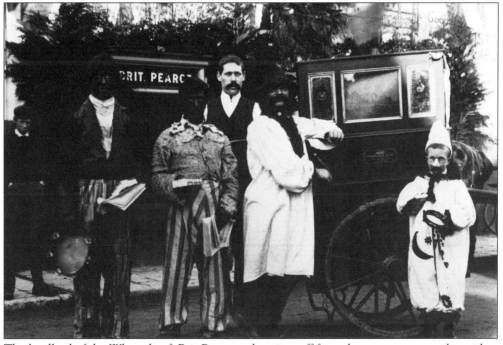

The landlord of the Wheatsheaf, Brit Pearce, takes time off from the pumps to pose alongside a barrel organ and its colourful crew in 1906.

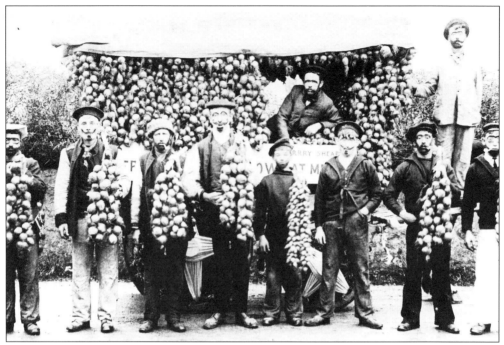

Titchfield folk showing that they know their onions as well as their strawberries in the 'French onion sellers" float, *c*. 1912.

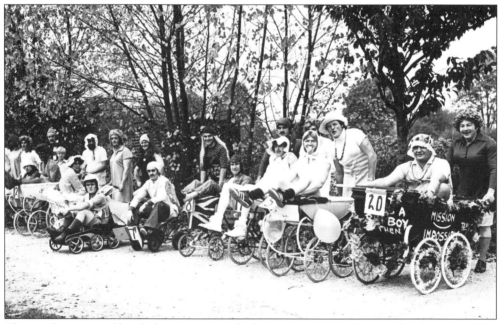

This motley group of local 'drag queens' with their mature babies line up for the start of the carnival pram race in 1978. All the money collected in the afternoon and evening processions goes to charity.

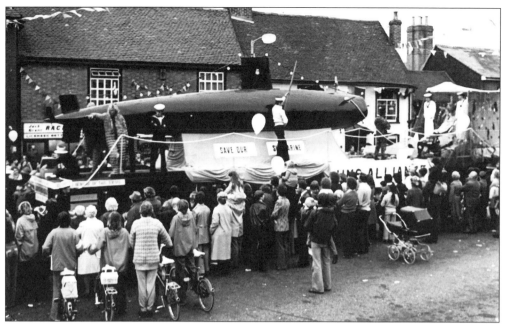

The HMS *Alliance* Submarine Museum float from Gosport passes through Titchfield during the bonfire carnival of 1978. The number of floats are such that they take over an hour to pass

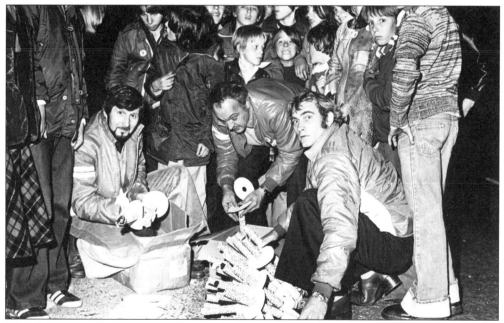

Titchfield carnival, 1978. The photograph shows the torches being lit and handed out for the evening procession, which ends with thousands of people invading the recreation ground for the fairground attractions, bonfire and firework display.

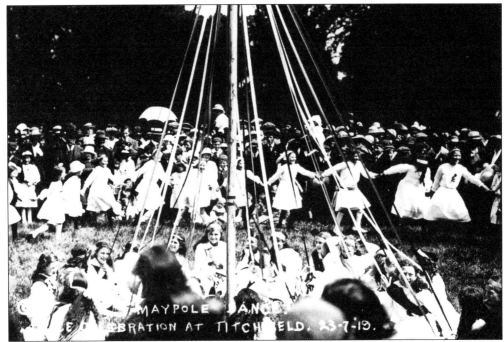

Dancing around the maypole at Titchfield, 1919. This traditional English custom has been maintained in local schools, long may it continue.

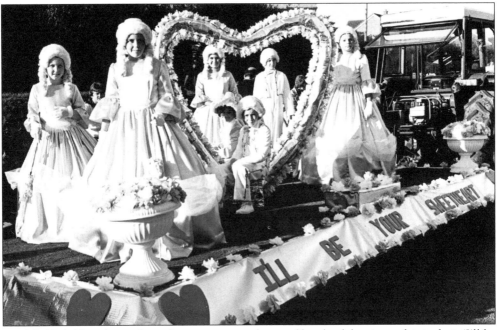

Titchfield children have always been an essential part of local celebrations, this is their 'I'll be your sweetheart' float in the 1979 procession.

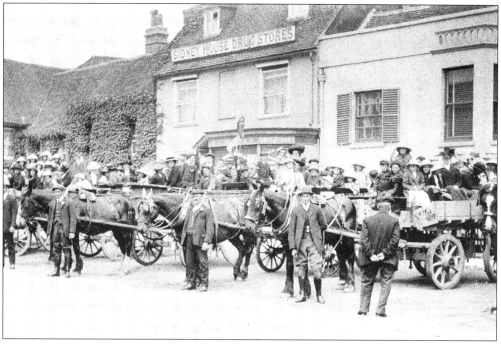

Sunday School Treat ready for the 'off' in Titchfield Square, 1914. On the way home the kids would sing: 'We've all been to the Treat, we've had enough to eat, we've filled our bellies with nuts and jellies, we've all been to the Treat'.

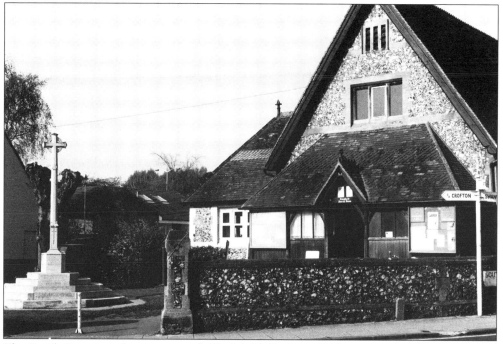

The Parish Rooms and war memorial, Titchfield. Built in 1890 as a memorial to Henry Hill Hornby, this building still plays a good role in village life, although Titchfield does boast a fine modern community centre off Mill Street.

Stubbington Village Hall, Bells Lane, 1923. Known locally as the Hammond Hall, after giving service as a venue for village activities for over ninety years, this building was demolished in 1997 amidst much controversy.

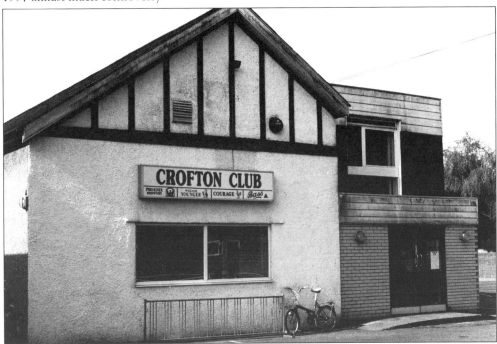

The Crofton Club, Titchfield Road, Stubbington. A working mens' club was formed in 1923 in a hut behind the old Malt House on the corner of Mays Lane, but it moved to the above site in 1928 to play a big role in the social life of the village.

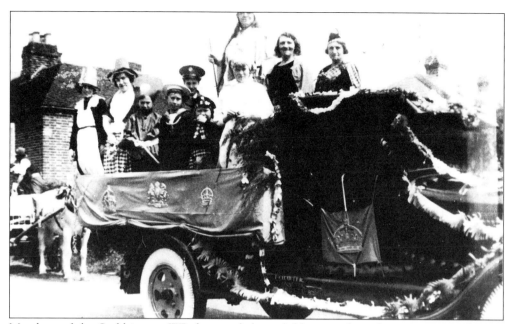

Members of the Stubbington WI choir and their children on their Coronation Day float in 1937. The local WI was formed in 1919, and in the 1920s and 30s its fine choir sang at many music festivals.

The local waterworks float at the 1937 Coronation celebrations. Piped water was introduced into Stubbington around 1922, before this water came from wells or the village pump on the Green.

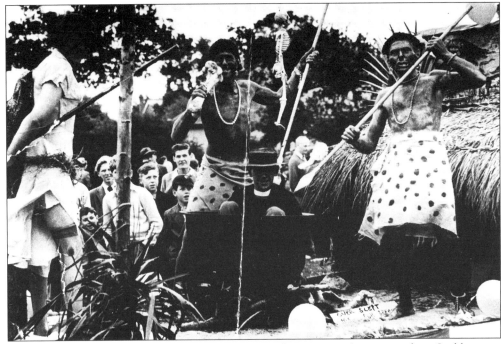

'One for the pot'. These bloodthirsty cannibals put the vicar on their menu for a Stubbington carnival in the early 1950s.

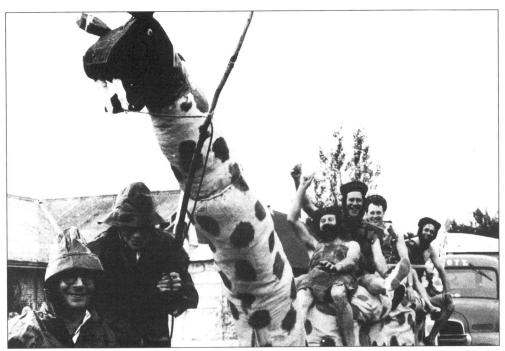

What a catch! These local fishermen got more than they bargained for when they caught the Loch Ness Monster at a Stubbington carnival in the 1960s.

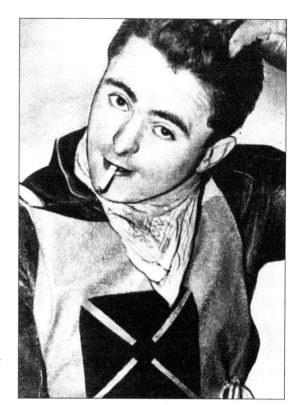

Ray Moore, New Cross and England, 1948. Real name Cyril, he was the son of bus and garage proprietor Ernie Moore and was born and bred in Stubbington. Alongside such speedway aces as Split Waterman, Norman Parker and Tommy Price, Ray was a member of the England team that rode against Australia in the 1948 test matches.

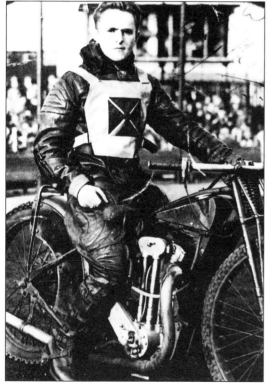

Following in his father's footsteps, Ray turned to the motor trade and ran a car sales business at Deptford. He also forsook his motorbike for car racing, which proved to be the cause of early demise at the age forty-four, for he was killed when racing at Oulton Park, Cheshire, on 21 March 1964.

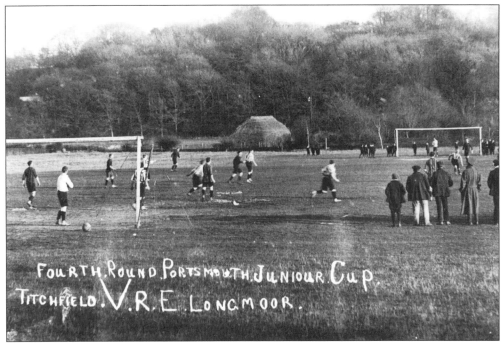

Titchfield FC playing at home on the recreation ground against the Royal Engineers in the 1930s. Titchfield had a very successful team during this period, winning many cups and championships.

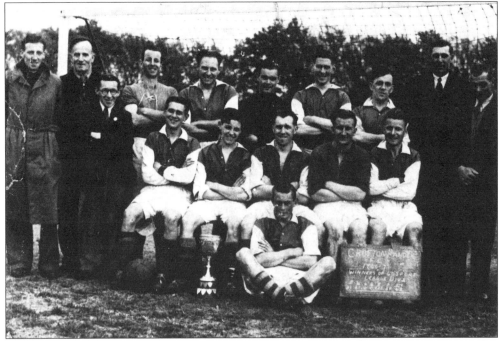

Crofton Rangers in the 1946-47 season. Not only did they win the Gosport Division, this outstanding side set a record that has never been beaten, playing and winning twenty-one matches, scoring a remarkable 122 goals for and only twenty-seven against.

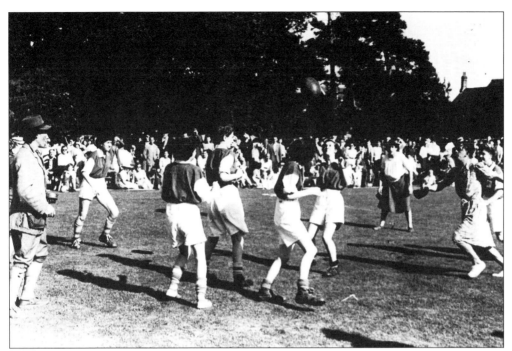

A ladies versus gentlemen football match is good for a laugh and for raising money for charity, even better when the gents are dressed as females, as in this comedy game played on Stubbington Park in 1954.

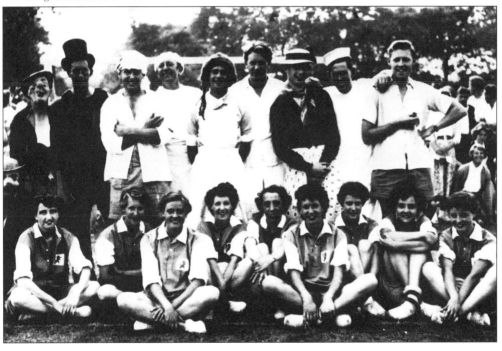

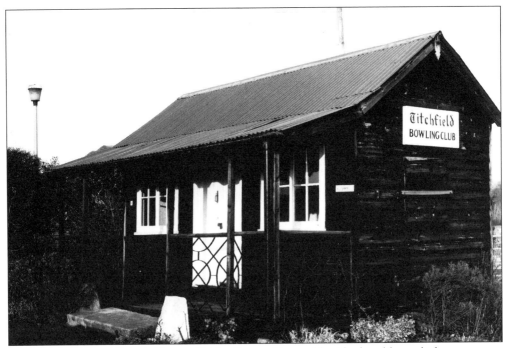

Titchfield Bowling Club clubhouse, Bridge Street. Situated beside the old canal, the greens are indeed in a most pleasant spot. The Titchfield Bowling Club was opened in 1923.

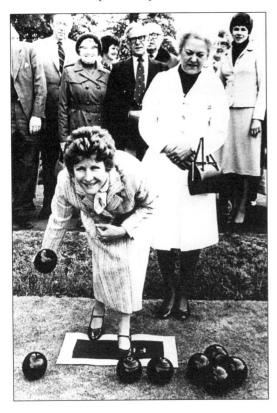

The Mayor of Fareham, Rosemary Pockley, bowling the first wood on the new green at Stubbington, 1980. Although not as old as the Titchfield club, it is popular with senior members of the community and the greens are busy during the season.

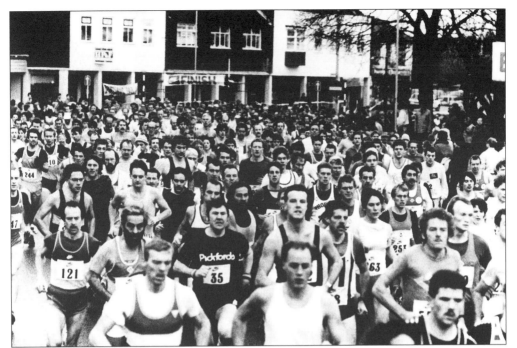

Runners pour out of Stubbington Green for the 1987 ten kilometres road race. The Green is a scene of great activity for this annual event, attracting runners from all over the country. Stubbington Green Runners, which began in 1985 with fifteen members, currently boasts a membership of 336.

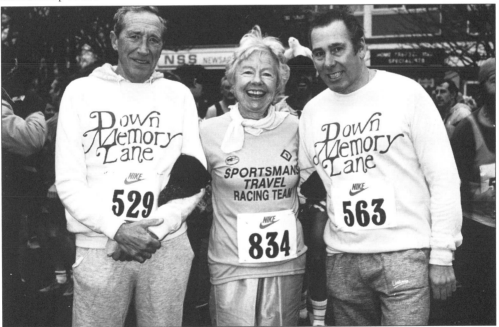

Renowned veteran runner Madge Sharples poses with two other veteran runners at the 'Stubbington Ten Kilometres'. Madge, who has run marathons all over the world, is still running in her eighties.

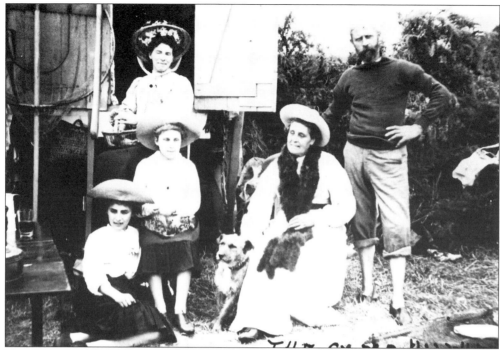

The Camp, Hill Head, 1906. In those halcyon summer days of yesteryear, long before 'air miles' had been heard of, what better than to camp in a lush field only a short walk from the seashore?

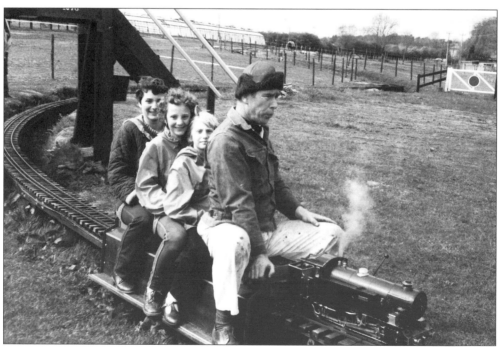

These children enjoy a ride on a miniature railway society loco at Carron Row Farm, Titchfield, in 1978.

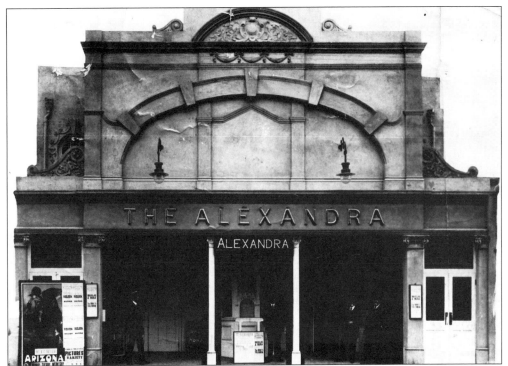

The Alexandra cinema, Fareham, *c.* 1926. This was Stubbington and Titchfield's nearest cinema, until it closed in 1933, it was only three miles away. A colourful character called 'Gypsy Joe' from Titchfield was a regular patron, during cowboy films he would 'whoop and shout' and gallop up and down the aisles.

A 1950s coach outing from the Sun inn, Stubbington, when Bob White was the landlord.

Peel Common Evangelical church outing, 1950. When the Hardiman's died, their son-in-law Alfred Munday took over, and Alfred in turn was succeeded by his son Clifford Munday.

Robert's Circus, Crofton Manor Farm Field, 1995. This particular circus attracted demonstrations by animal lovers, who protested that it was sited but a hundred yards away from the RSPCA 'Noah's Ark' animal sanctuary in Stubbington.

Seven

Historic Buildings

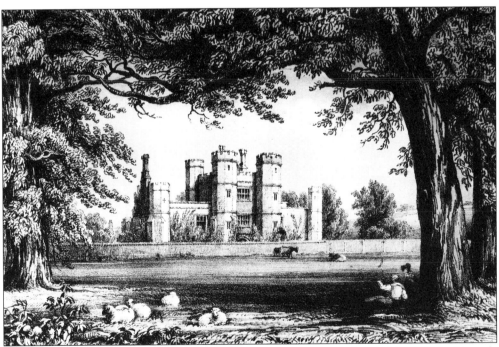

Titchfield Abbey, 1842. Titchfield's most famous monument was founded in 1232 by Peter de Roches, Bishop of Winchester, and was occupied by the Premonstratensian White Canons for 300 years. The abbey was built of stone brought over from the Isle of Wight.

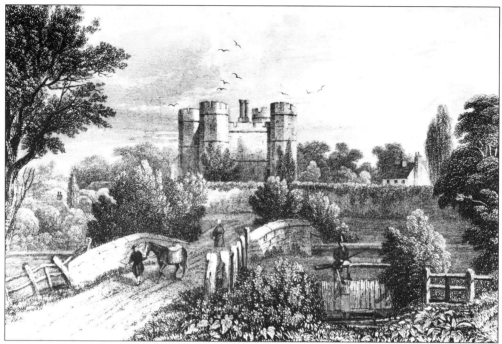

Titchfield Abbey from the Anjou Bridge in the early 1800s. When staying at the abbey in 1393, King Richard the Second and his Queen, Anne of Bohemia, were presented with a petition of grievances by the villagers of Titchfield, who strongly denounced war and the oppressive taxes.

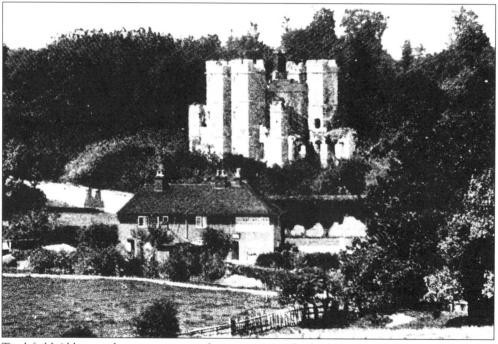

Titchfield Abbey in the same view as above, *c.* 1910. The building in the foreground was the Railway inn, built in the 1880s to cater for the workers building the railway between Fareham and Southampton. The pub is now called the 'Fisherman's Rest'.

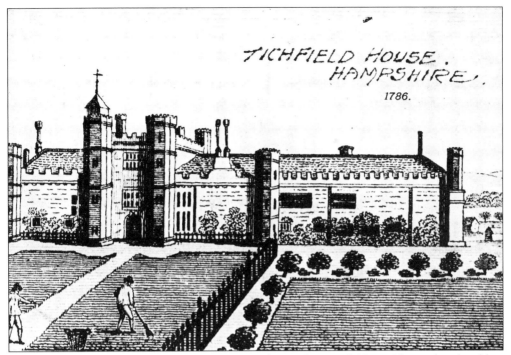

Titchfield Abbey, also known as Place House, as depicted in 1786. Henry V stayed at the abbey on his way to France and subsequently glory at Agincourt in 1415, and thirty years later Henry VI went there to await his bride, Margaret of Anjou. The nearby bridge was named after her.

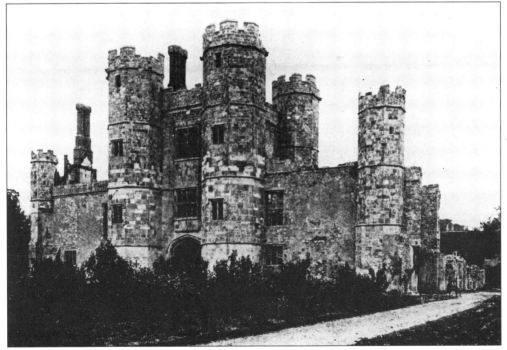

Titchfield Abbey, c. 1930. After the Dissolution of the Monastries, Henry VIII gave the abbey to the Earl of Southampton, who transformed it into a mansion which he called Place House.

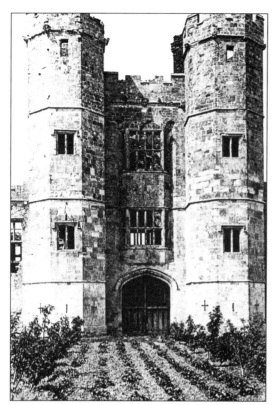

Titchfield Abbey, the south front of the gate house, 1930s. Elizabeth I visited Place House in 1569, and William Shakespeare stayed there in later years. The Great Bard, a friend of the Third Earl of Southampton, is supposed to have written his *Romeo and Juliet* here during one of his visits. By 1741, this historic building was in the hands of the Delme family, and when Peter Delme had Cams Hall built at Fareham much of Place House was dismantled for building materials, including stone, brickworks, oak beams and panelling.

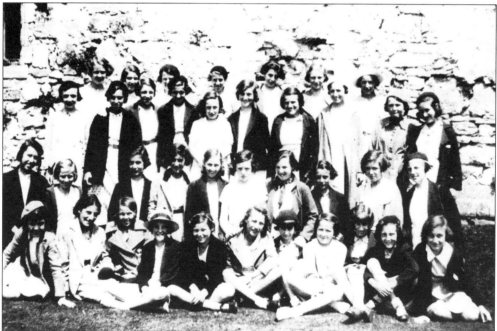

Northern Parade Senior Girl's School, Portsmouth on a visit to Titchfield Abbey in 1935. The ruins are still a popular tourist attraction, not only for schools, but also for musical concerts, plays and wedding photographs.

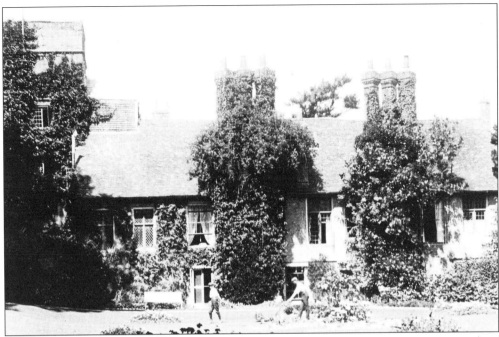

St Margaret's Priory, St Margaret's Lane, Titchfield. Built as a dower house by the Earls of Southampton about 1560, both of these pictures were taken around 1910. The five-storey tower was built as a watch tower at the time of the Spanish Armarda when Titchfield was a seaport, commanding fine views of the Solent. We cannot be certain whether Shakespeare entered this house, but he would have certainly seen it on his visits. It is now a private residence.

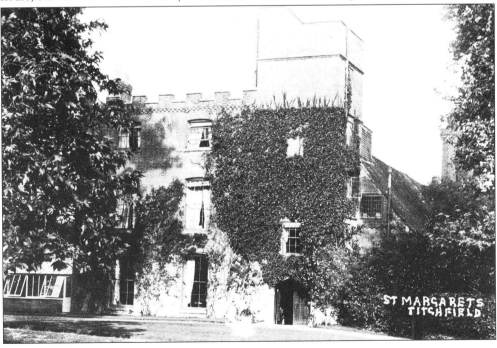

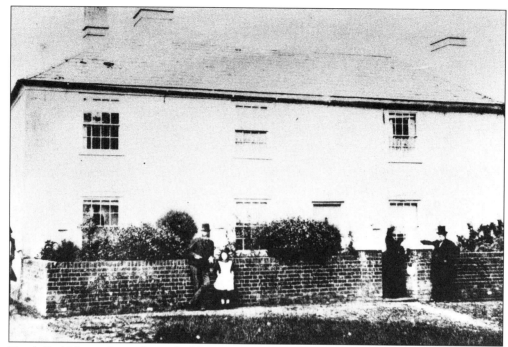

North End House, Longs Lane, Stubbington, 1872. The deeds to this house date back to 1760, by the turn of the century the left part of the building had been converted into a grocery shop, and currently serves as a TV repair shop. From 1945 until 1968 the house was used for the Stubbington telephone exchange.

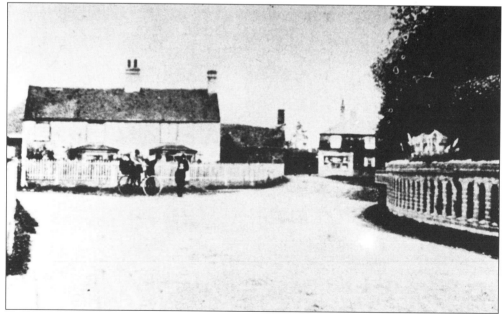

The Old Malt House on the corner of Titchfield Road and Mays Lane, c. 1910. North End House can be seen up the lane past the wall on the right, the shop was occupied by the Gosling family as a grocers. The Malt House was demolished in the mid-1930s when in the possession of Fielder's Brewery.

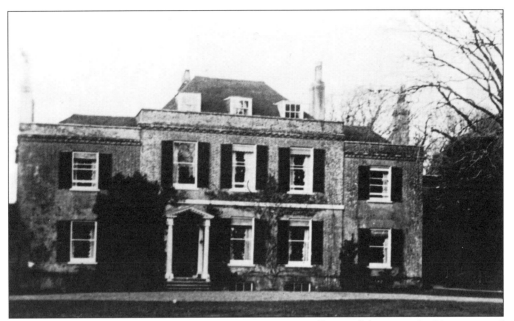

Holam House, Crofton, *c.* 1908. Situated at the top of Hollam Hill between Stubbington and Titchfield, this once magnificent Georgian mansion can still be seen, although closed at present after serving as a nursing home for some years.

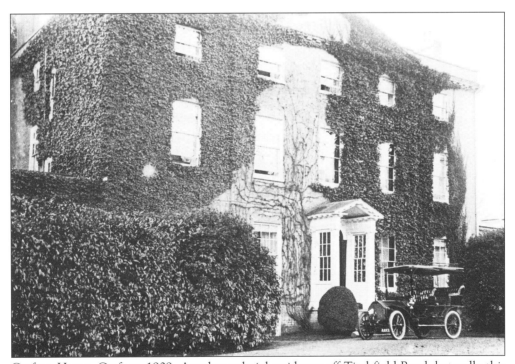

Crofton House, Crofton, 1909. Another palatial residence off Titchfield Road, but sadly this eighteenth century mansion is no longer standing, destroyed by fire in 1972 after laying derelict for some years.

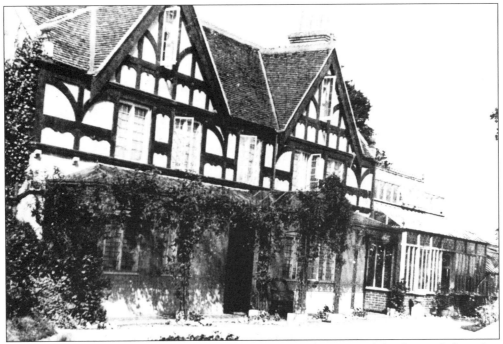

Burnt House, Burnt House Lane, Stubbington, c. 1903. The name of this lane is believed to have derived from a fire in earlier times that destroyed a thatched cottage. At the time of this photograph the house was in the hands of the Caley family.

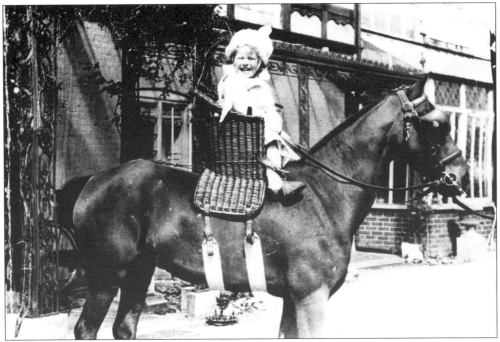

Miss Marjory Caley demonstrates her equestrian prowess outside Burnt House, for although Captain Caley was a seafaring man, he had a good stable of horses. The author admits to never having seen a purpose-built cane riding chair until this charming picture.

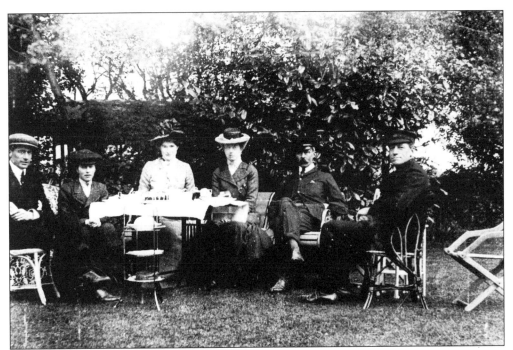

The Caley's entertain Princess Victoria of Hesse (the third from the right) at Burnt House, c. 1903. The Caley's moved in high circles, for he was Captain of the Royal yacht *Victoria and Albert*. King Edward VII and Queen Alexandra visited Burnt House on at least one occasion.

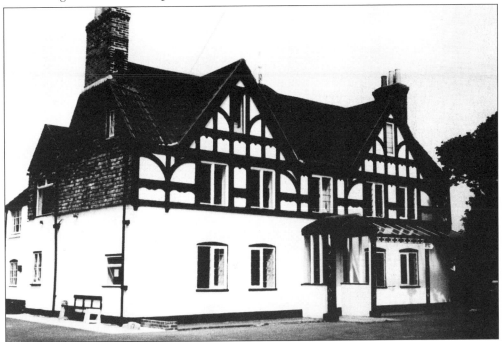

Burnt House, 1988. Meoncross School took over Burnt House in the 1950s, since then it has been extended with additional buildings to accommodate over 400 pupils. The original building looks very much the same as in the 1903 picture opposite.

Cuckoo Cottage, Cuckoo Lane, Stubbington. This charming early seventeenth century farmhouse once stood in splendid isolation, but today it is surrounded by housing, most of which was introduced in the 1950s and 70s.

Anker Cottage, Titchfield Road, Crofton. This imposing fifteenth century thatched house is reputed to have been used for smuggling purposes in the eighteenth century, and certainly the name Anker is from a Dutch word meaning 'a keg of spirits'.

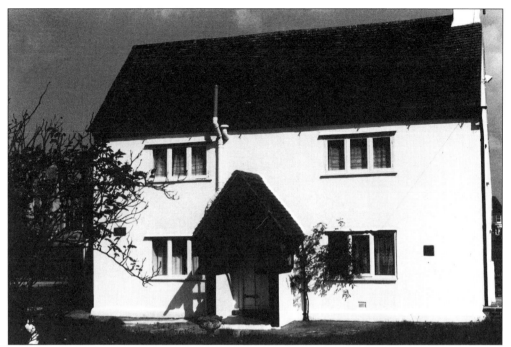

Steamboat Cottage, Stubbington Lane. Formally called Dairy Cottage it was lived in by a head cowman who worked for the Foster's of Stubbington House. It was later acquired by the late Basil Ripley, a vintage car enthusiast and marine engineer - hence the name 'Steamboat Cottage'.

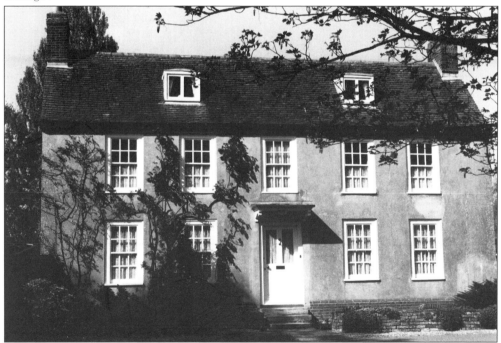

Old Park House, Park Lane, Stubbington. This fine eighteenth century house was once part of the Stubbington House estate and occupied by teachers and school staff.

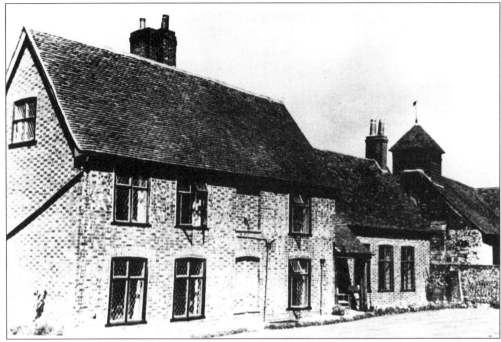

Crofton Manor, Titchfield Road, Crofton. Situated next to Old Crofton church, parts of this charming manor house date back to the sixteenth century. Over the years it has served as a hotel and rest home.

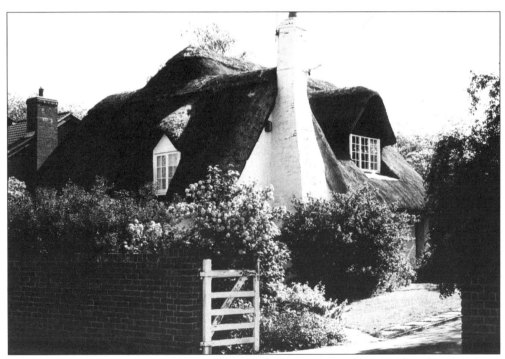

The Thatch, Mays Lane, Stubbington. Despite the increasing flow of traffic that thunders down the lane, this delightful sixteenth century cottage languishes sedately behind a garden wall.

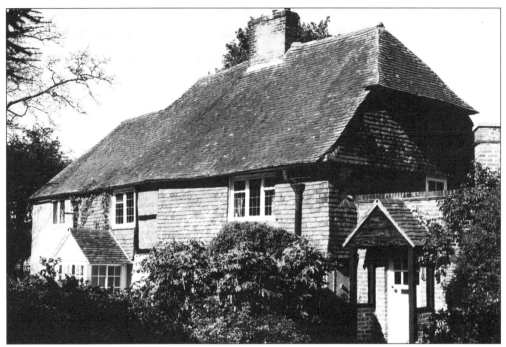

Smugglers Cottage, Crofton Lane, Stubbington. This four hundred year old building certainly had smuggling connections including a secret passage running under the house to the garden.

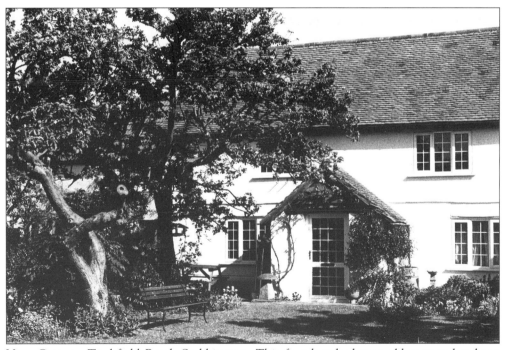

Vine Cottage, Titchfield Road, Stubbington. This four hundred year old cottage has been carefully preserved over the years, it contains many original beams and boasts two staircases for it was formerly two cottages.

Burnt House Cottages, Burnt House Lane, Stubbington. These cottages were previously thatched, and bearing in mind how this lane got it's name, it is interesting to reflect that some of the roof timbers show signs of having been scorched by fire.

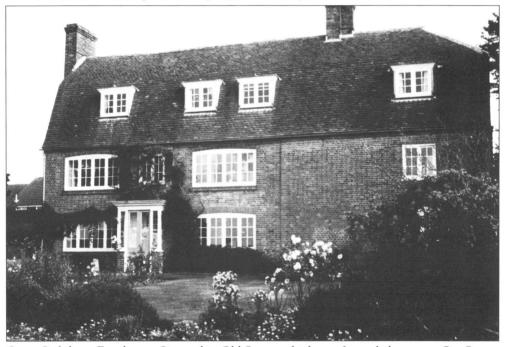

Great Crabthorn Farmhouse. Situated in Old Street, which was formerly known as Ore Street, this imposing eighteenth century building once dominated a small hamlet north of Hill Head known as Crabthorn.

Eight
Time Gentlemen, Please

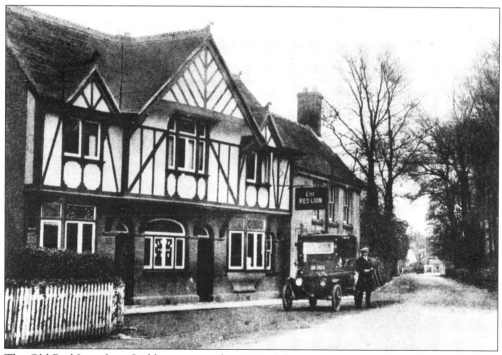

The Old Red Lion Inn, Stubbington, in the 1920s. Like water pumps and churches, pubs have always played their part in village life. At one time Stubbington had three pubs or beer houses on or near the Green, but today it only has the new Red Lion.

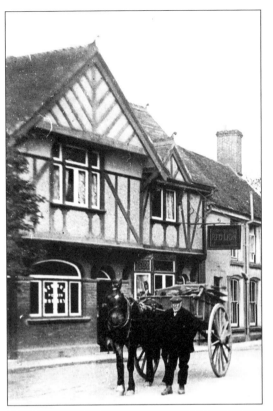

The Red Lion, 1909. This pub was a popular place or stopping point for fox hunts and coach outings, at one time there was a mounting stone outside for getting onto horses. In the 1960s a new Red Lion was built adjacent to the old inn, which was duly demolished on completion. The rare photograph below shows the old and the new Red Lion, before the service road by Bugden's supermarket was built on the site of the old pub.

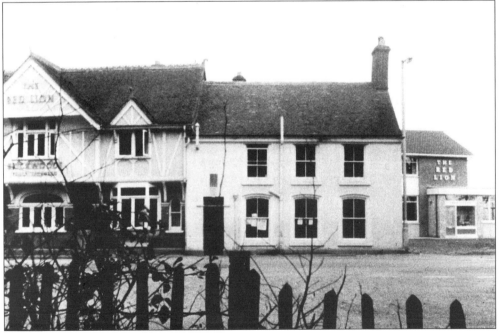

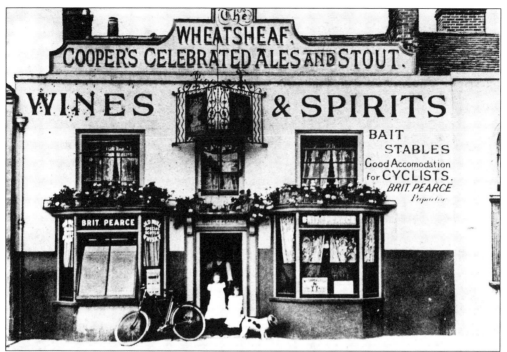

The Wheatsheaf, East Street, Titchfield, *c.* 1906. This ancient hostelry is the epitome of an English village pub, and has changed little from these pictures. It is interesting to see that apart from providing accommodation they also catered for horses and cyclists, although the sign writer would have no doubt been choked to discover that he had left an 'm' out of accommodation.

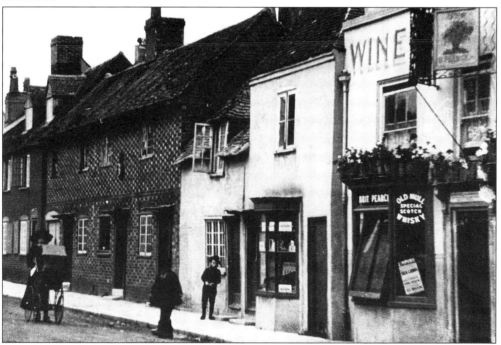

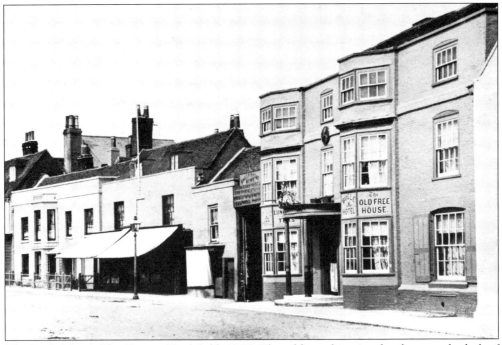

The Bugle Hotel, The Square, Titchfield, 1905. This old coaching inn has been at the hub of the village for hundreds of years, the top floor fascia is of particular interest, it is false with the windows being purely cosmetic with nothing immediately behind them. The lower picture was taken ninety years later at the time of the VJ celebrations in 1995, which included live bands and dancing in the street.

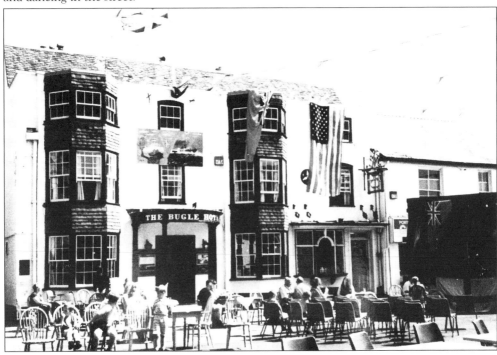

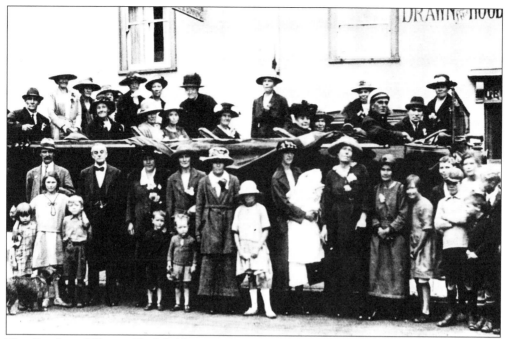

The Coach and Horses, Titchfield, c. 1921. This old inn at the bottom of Coach Hill has been traced back as far as 1780, when this picture of a charabanc outing was taken, the landlord was George Binnings, the gentleman standing at the front in a bow tie.

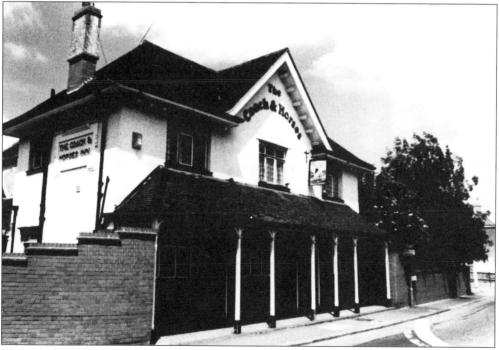

The Coach and Horses was rebuilt in 1925 for the Portsmouth United Brewery (PUB), this photograph shows the pub pretty much as it is today. Ernie Matthews was the popular landlord here in more recent times, from 1968 to 1992.

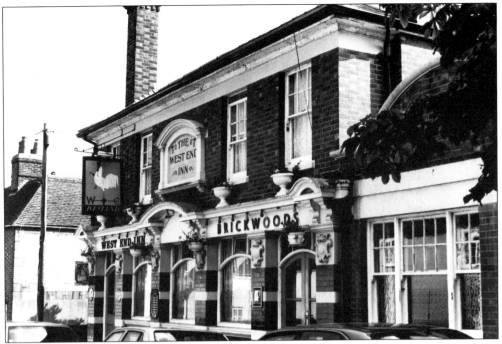

The West End Inn, West Street, Titchfield. Despite protests from its regulars and CAMRA (Campaign for Real Ale), Whitbread closed this popular pub in 1990.

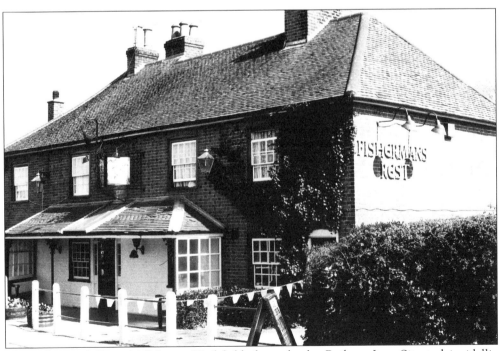

The Fisherman's Rest, Mill Lane, Titchfield, formerly the Railway Inn. Situated in idyllic surroundings, the abbey at the front and the River Meon at the rear, this is a popular pub with tourists and visitors to the abbey.

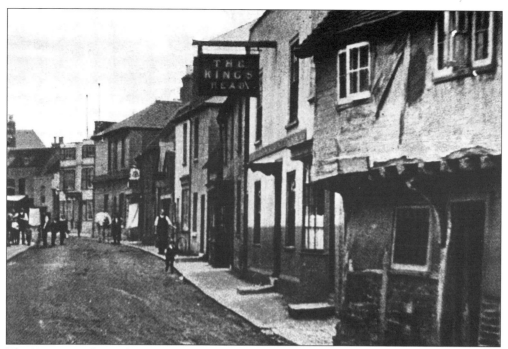

The King's Head, South Street, Titchfield, *c.* 1910. This pub closed some years ago, it is now a private residence named 'Cordwainers'. Another pub, the Red House, further down South Street, closed in 1921.

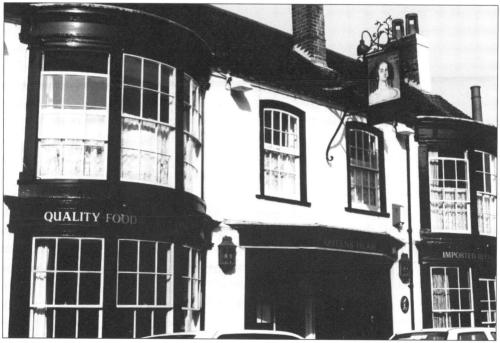

The Queen's Head, High Street, Titchfield. This old inn has been at the heart of village life for many years, but the Clarendon inn, which was not far away on the East Street corner, has been converted to a private house.

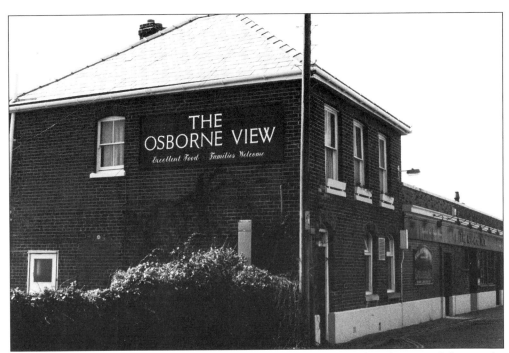

The Osborne View, Hill Head. Another former Fielder's Brewery pub, it has graced this site for over one hundred years, although it has been extended considerably over the years to command splendid views of the Solent and the Isle of Wight. The lower picture, taken from the beach, shows the rear of the Osborne View.

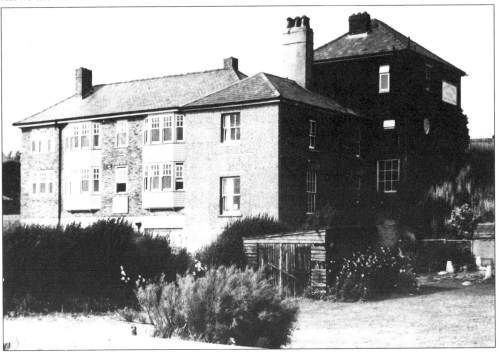

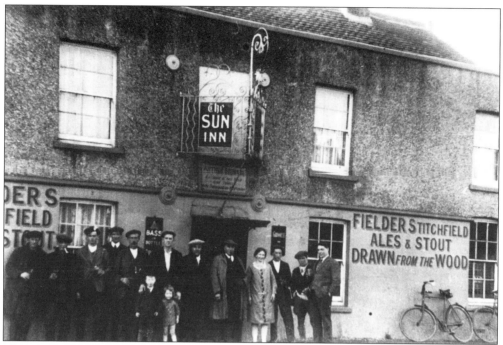

The Sun inn, the Green, Stubbington, when Arthur Browning was the landlord in the 1930s. Fielder's Brewery of Titchfield were one of the last breweries left in the area, serving around ten pubs locally. The lower picture shows The Sun inn shortly before it was demolished in the 1960s to make way for the modern block of shops that now includes Iceland.

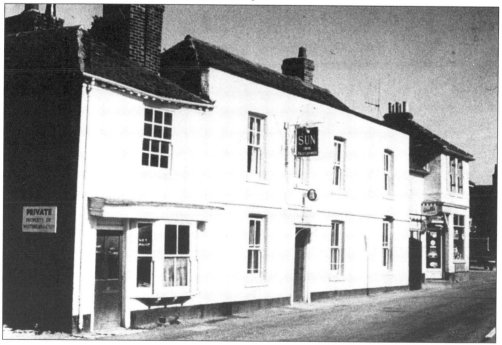

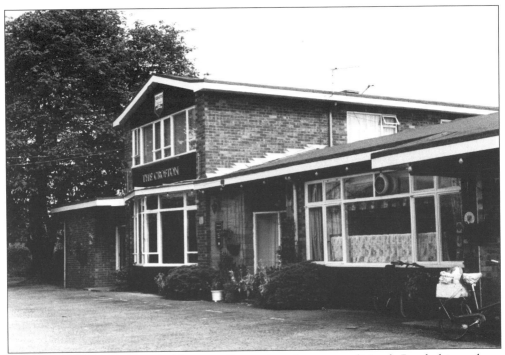

The Crofton, Crofton Lane, Stubbington. Situated on the corner of Moody Road, this modern-style pub has been in existence over twenty years as a popular meeting place.

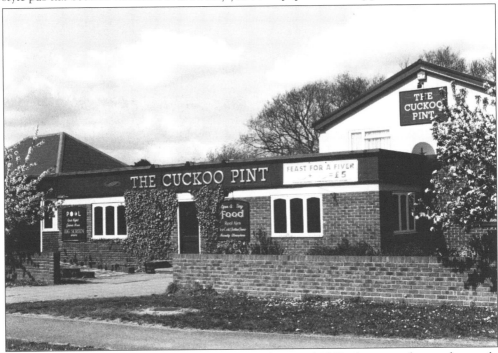

The Cuckoo Pint, Cuckoo Lane, Stubbington. Built around 1980, this is another modern-style pub that caters for the large housing development that took place around that time to the west of the village.

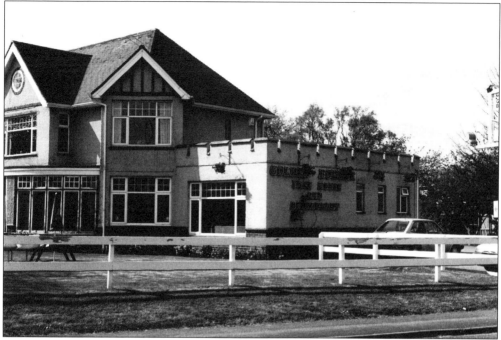

The Golden Bowler, Stubbington Lane, Stubbington. Formerly overlooking open fields once worked by Hammond's, this pub now enjoys custom provided through housing development over the past thirty years.

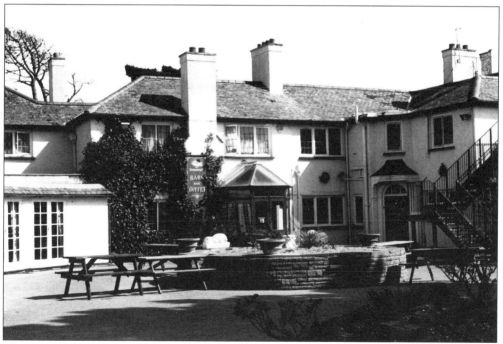

The Swordfish Hotel, Sea Lane, Stubbington. On the coastal road where Stubbington meets Lee-on-the-Solent, this pub and restaurant derived its name from the Fairey Swordfish aircraft which once operated from nearby *HMS Daedalus* in the Second World War.

Acknowledgements

Although most of the photographs were taken from my own collection, I am extremely grateful to a number of people who kindly provided additional material.

I wish to acknowledge contributions from Tony Tubb, Peter Tubb, Roy Cummings, Sheila Towler, Stan Budge, Barbara MacGregor, Ernie Matthews, Sylvia Bates, John Sadden, Betty Grant, Bill Reed, Dennis Woodward, Pat Woodward, Frank Lewis, Father Brian Rutledge, Mike Fitzmaurice, David Jacobs, Robert and Caron Donahue, and my friends and colleagues at the *Portsmouth News*.

Further Reading

Life in Late Seventeenth Century Stubbington - Stubbington WEA Local History Group
A look at Stubbington 1850-1875 - Stubbington WEA Local History Group

Stubbington and Hill Head, Land and People - Stubbington and Hill Head History Society
Reminisences of Stubbington Village Life - Stubbington and Hill Head History Society

A History of Stubbington - Colin Prestidge

Titchfield - A History - Titchfield History Society
Titchfield - A Place in History - Titchfield History Society

Titchfield Village Walk - Titchfield Village Trust